For Jodi

Sarasvati's Gift

with my love

5/10/22

mayumi Oda

植

Also by Mayumi Oda

Divine Gardens

Facing Hawai'i's Future: Harvesting Essential Information About GMOs, edited by Nancy Redfeather, with Solomon Robert Nui Enos

Goddesses

Happy Veggies

I Opened the Gate, Laughing: An Inner Journey

Random Kindness and Senseless Acts of Beauty, with Anne Herbert and Margaret Paloma Pavel

The Safe Energy Handbook: Towards a Solar-Economy Future (25th anniversary edition), *foreword & illustrations* by Mayumi Oda, *Handbook* by Claire Greensfelder, Sensei Kazuaki Tanahashi, and other INOCHI board members

Sarasvati's Gift

The Autobiography of Mayumi Oda—
Artist, Activist, and Modern
Buddhist Revolutionary

Mayumi Oda

Foreword by Robert A. F. Thurman

SHAMBHALA

Shambhala Publications, Inc.
4720 Walnut Street
Boulder, Colorado 80301
www.shambhala.com

Cover art: Mayumi Oda
Cover photo: Roshi Joan Halifax, Abbot, Upaya Zen Center
Cover design: Gopa & Ted2, Inc.
Interior design: Gopa & Ted2, Inc.

9 8 7 6 5 4 3 2 1

First Edition
Printed in Canada

♾ This edition is printed on acid-free paper that meets the
American National Standards Institute Z39.48 Standard.
♻ Shambhala Publications makes ever effort to print on recycled paper.
For more information please visit www.shambhala.com.
Shambhala Publications is distributed worldwide by
Penguin Random House, Inc., and its subsidiaries.

Library of Congress Cataloging-in-Publication Data
Names: Oda, Mayumi, 1941– author. | Thurman, Robert A. F.,
writer of foreword.
Title: Sarasvati's gift: the autobiography of Mayumi Oda—artist,
activist, and modern Buddhist revolutionary /
Mayumi Oda; foreword by Robert A. F. Thurman.
Description: First edition. | Boulder, Colorado: Shambhala, [2020] |
Includes bibliographical references and index.
Identifiers: LCCN 2019040808 | ISBN 9781611808155 (trade paperback)
Subjects: LCSH: Oda, Mayumi, 1941– | Artists—United States—Biography. |
Japanese American artists—Biography. | Buddhists—United
States—Biography. | Pacifists—United States—Biography.
Classification: LCC N6537.O275 A2 2020 | DDC 700.92 [B]—dc23
LC record available at https://lccn.loc.gov/2019040808

✦

SARASVATI HAS BEEN MY GUARDIAN GODDESS since childhood. All my life, I've called on Sarasvati for guidance, protection, and inspiration. She is the Hindu goddess of music, art, and wisdom, and she's mentioned in the *Rig Veda* around 1500 B.C.E. One morning in the early 1990s, as I sat in meditation in front of the statue of Goddess Sarasvati at my home north of San Francisco, I heard her say in a loud voice, "Stop the plutonium shipment!"

I was stunned. I took a breath and said, "I can't do that. I'm only an artist," and she answered, "Help will be provided."

This book is dedicated to all women warriors and to my godchildren, Tajha Sophia Chappellet Lanier and Angus Galen McCleary, both born in October 1992—when I became fully engaged in creating a path toward peace, justice, and compassion.

✦

Contents

List of Illustrations

Foreword

S ARASVATI'S GIFT, Mayumi Oda's great gift—how wonderful to receive it in this beautiful, heartfelt, honest book. Sarasvati, the goddess of art, the Lady of the River of Beauty, is the cleansing divine flow of the waters of truth and beauty, and she emanates to heal and cleanse our stressed-out lives on our stricken planet through the undaunted art and golden heart of Mayumi Oda.

I have known Mayumi since 1966, when our two families were just starting to have our wonderful children. We have walked through the decades since then, each on our own distinct Buddhist paths but ultimately shoulder to shoulder in the direction of the victory of truth and love in the golden future of this planet, trying not to get too stressed or to give in at all through the long tunnel of obstacles under the self-destructive leadership of obsolescent elites. This book is a revelation of the glory of her determined artistry, filled with all the kindness, beauty, and power that flows from the indomitable feminine, divine as nature, of nature, in nature, gentle and nurturing and ferocious in the defense of life. It chronicles her discovery of our mother Gaia's inconceivable gracious abundance to us humans, giving us the opportunity to thrive in joyful celebration of her grace. Only when I read this book did I finally learn so much more of Mayumi's youth, of her sufferings from a war-torn childhood, and understand more deeply her dreams, insights, bravery, and irrepressible creative force. I also heard more keenly than ever her bone-deep, marrow-piercing message to us all to wake up, stop at once our busyness-as-usual, step back from our sleepwalking into catastrophe, and turn away from the path of greed, hostility, and delusion, to restore our world—our earth, our oceans, our fire, our air, our space itself—and recover the joy of care and creativity, taking up the

universal responsibility to make everyone enjoy the unending time we will face together on this planet.

Mayumi and I were born the same year, 1941, and that sweet child with the sensitive soul of a fine artist had to cower in a homemade bomb shelter during the fire bombings of Tokyo, culminating in the all-too-nearby nuclear horrors of Hiroshima and Nagasaki. She then had to grow up in a culture both rigid with samurai patriarchy and deeply traumatized by war and devastation, loss, and grinding privation. Kindness of family and friends and the expressiveness of art were clearly her salvation, and the experience of finding beauty in the rubble and turning stubborn love into creativity has been the triumph of her life, the great achievements of her art, and the depth and urgency of her teaching and its activism for life.

As I read the book alone in my study, it brings me to tears, thinking of her suffering as a child. I marvel at how succinctly but thoroughly she chronicles the huge transformations the world has suffered and achieved in our lifetimes. Her life itself testifies to how we have come on the people level, in spite of gigantic and intensifying dangers and catastrophes, truly to a new age of gentleness, sustainability, recovery of human intelligence, love, and creativity. Her art and her activism, how it faces obstacles, also show how we all still seem to be driven toward doom by insane leadership, a relative few sad but powerful people still imprisoned by habit patterns of ignorant, outmoded-but-obstinate convictions, personal rigidity, male chauvinist arrogance, and escapist self-destructiveness based on the subliminal nihilism of "scientistic" materialism.

Aloha, e lo, life! Mayumi radiates it from her person and in her monumental, iconic art. She is inspired by the Tibetan word *thang-ka*, literally "scroll plane opening," for each icon—*thang* meaning flat plane or expanse, like a plain, a steppe, the floor of a valley; and *ka or kha*, a face, an opening. In Tibetan art, such scroll icons are seen as windows from our ordinary world of habitual perceptions into the sacred world of higher beings, embracing environments, inspiring realities. What we glimpse through those windows are deities, teachers, allies, havens, beneficial energies that inspire us to see more precisely, feel more deeply, understand more fully

the realities of our worlds and the greater possibilities of our continuum of lives.

Mayumi's works serve perfectly in that tradition, and, as with the best of it, are completely original. They express the presence of wisdom, its flowing with the indomitable power of universal love as kindness, care, tireless responsibility, and humorous self-confidence. If any art of our time expresses the irrepressible female, in all its magnificent aspects, beauty, sensuality, generosity, no-nonsense realism, tenderness, and even ferocity, it is the art of Mayumi Oda.

It is a privilege and a pleasure to welcome the book, lighting a small candle of praise at the altar of divine holiness, Sarasvati, and her lovely, worthy, and delightful emanation, Mayumi Oda!

Robert A. F. "Tenzin" Thurman
Jey Tsongkhapa Professor of Buddhology
Emeritus, Columbia University
Cofounder of Tibet House US
Woodstock, New York, June 17, 2019, Vaishakha Full Moon

Mayumi's Artistic Vision

U NLIKE MOST UNHERALDED SOULS whose family trees are empty of professional artists, I arrived into the world with an announcement in silk screen on a small sheet of pink rice paper. Smooth and white against the dimpled grain, the image—envisioned even before I left the womb—would constitute my very first portrait: a laughing baby cradled by peonies, drawn in supple strokes by Mayumi Oda.

Mayu, as we call her in my house, was my father's first wife and is the mother of my two half brothers. My family's relationship with her has always been unconventionally close; throughout my life, she remained a sage figure of female strength and moxie, second only to my own mother. And while her vibrant tableaux grace the walls of homes, galleries, and museums around the world, I daresay my connection to her work is deeper, as it constituted the fundamental aesthetic environment of my youth.

Indeed, I came into consciousness as a human, and as a woman, against a landscape of abundance and fertility: ample bosoms, powerfully seeing eyes, full arms and lips, rolling waves and puffy fish, skies churned by storm. With their lush, saturated colors, Mayumi's paintings were my world, and her vision of the natural domain and of our role in it became for me as invisible—which is to say, as obvious—as breathing.

For Mayumi, the development of this perspective was inevitable. From the moment she set her Japanese writing brush to paper as a young girl of sixteen, she was determined to devote her art to one idea, and after all these decades, she has never wandered far from it. The subject that flowed naturally from her brush was a searing vision of the emancipated woman, the woman as Goddess, the woman in all her Rubenesque nakedness, bound between the miraculous realms of earth, sea, and sky. At Mayumi's hand, Woman took her place beneath a universe of stars that both dwarfed and

glorified her, rooted her in an earthly context while expanding her meta-phorically into a sublime connection with the cosmos.

Grounded in stunning detail and at the same time allegorical, embody-ing a profound capacity for lyric amplification, Mayumi's latest work is a breathtaking series of thangkas, where her love for and faith in Woman has been realized into images as quietly meditative—yet full of inner fire—as a prayer. Like the thangkas, Mayumi's compositions are as complex and lay-ered as a life, capturing the force that draws us all together, and the infinite shades, facets, and incarnations inherent to existence. *Sarasvati's Gift*, they teach us, is the gift of knowledge, music, arts, wisdom, and learning—the transformative, and then transferable, elements of every individual human life that can be sowed again and again, planted like seeds in a fecund earth, eternally reawakening and regenerating the universe, ever anew.

Emily Nathan

Artist's Note

WHEN I DECIDE to paint a certain deity, such as those you will find in many of the thangkas contained in this book, I thoroughly research both the Japanese and Tibetan historic visions of the figure. I research Buddhist iconography. For inspiration, I go back to Japanese prehistoric cultures, such as that of the Jōmon period. And not only the history of my own culture—I also study images of other ancient cultures such as that of Mesopotamia. I go through many, many images.

My painting requires a lot of concentration. For most of the thangkas, I did the tracing of the *Heart Sutra* every day as preparation. It is a Buddhist practice called *Shakyo*, which is mindfully tracing sacred scriptures. This brings concentration and serenity, so I can enter with a pure and clear mind to paint thangkas. I do meditation every morning and evening, sometimes in a temple, sometimes at home.

<div align="right">Mayumi Oda</div>

Preface

I WAS BORN IN TOKYO, Japan, in 1941, and when I was four years old, atomic bombs were detonated above Hiroshima and Nagasaki. Seeing news coverage of blackened, ash-covered bodies and shadow images of people imprinted on concrete with no trace of their flesh or their lives was a horror that affected me profoundly. My family had been evacuated from Tokyo before the bombings, and when I returned home six months later, we saw survivors of the atomic bombs as well as severely wounded soldiers begging for alms on the streets. Some carried photos of the horrible aftermath of the atomic bombs, and from these pictures I imagined and could even feel these horrific events. I could smell death and hear the screams of survivors crying for help, for water, for anything to relieve their pain. "Mother!" they would wail. I saw this in my mind's eye for years, and when I was seven, I finally understood what had happened—I knew the inhumane and grotesque destruction of an atomic bomb. This reality of war and nuclear holocaust was the unceasing nightmare of my childhood. When J. Robert Oppenheimer, director of the Manhattan Project, had seen the first atomic fireball rise into the sky at Alamogordo, New Mexico, in July 1945, he quoted from an ancient Hindu Veda, "Now I am become Death, the destroyer of worlds."

When American scientists split the atom, something terrible happened to us as humans. We violated the integrity of nature and invaded God's domain. When an atomic bomb drops, it wipes out *everything* that anyone could care about. It destroys men, women, children, and animals. It poisons soil, sky, rivers, and oceans for generations. It demolishes buildings, homes, and even entire cities, and tears at the flesh of our hearts, minds, and souls. This violence has affected and infected us ever since the Manhattan

Project during World War II unleashed these gods of war and their deadly by-products, such as plutonium. Gaining the power of gods, we left a lethal legacy to our children and descendants.

I believe the world's media has been prevented from reporting on the prevalence of radioactivity due to patriarchal power—the control of the many by the few, the dominance of the masculine over the feminine. It's not simply about men and women but whether we use our God-given strength for "power over," by which I mean patriarchy, or for "power with," the style of feminine nurturance. Patriarchal power requires secrecy and the control of information, and has been, all along, essential to the development and use of nuclear weapons and nuclear energy.

Atomic power is not only in weapons of mass destruction. It is causing untold harm to those who reside near nuclear energy plants and waste storage areas. The price we pay for electricity generated by nuclear power has been high fences, armed guards, an army of so-called experts unable to deal with the toxic messes they've created and their cover-ups. Disregarding the safety of present and future generations, the creators and promoters of nuclear power leave our children an unforgivable debt simply to heat water to turn turbines for electricity.

And the suffering continues today. Residents from the region of the 2011 Fukushima Daiichi nuclear disaster are now being paid to return to the area. Yet half the children who were near the Fukushima Daiichi Nuclear Power Plant during the meltdown, explosion, and release of radioactive materials now have precancerous cysts on their thyroids. Having survived the horrors of the carpet-bombing of Tokyo, followed by atomic bombs in Hiroshima and Nagasaki, and seeing people continue to suffer more than seven decades later from the meltdown of the Fukushima Daiichi nuclear reactors, I feel compelled to ask, What is really going on in military circles and in the civilian nuclear power industry? Have we learned nothing from our mistakes? Japan rests along one of the most active fault lines in the world, with a tremor occurring there every five minutes. With earthquakes so common, another nuclear disaster can happen at any time. It's as if the Japanese government and Tokyo Electric are ready to sacrifice their own people to prove that nuclear reactors are safe. They're not safe! Why are

residents being asked to return as though nothing happened? Is something being covered up?

Humankind has the intelligence to survive. We have come up with brilliant solutions such as the Marshall Plan after World War II and the Green New Deal today. When we face life's dangers head-on, there is an opportunity for both personal and global transformation. As solar technologies replace fossil fuels and solar-hydrogen technology turns water into energy; as we harvest energy from the sun, wind, and earth for homes, neighborhoods, communities, and regions; we are proving the viability of clean power and a safe and sustainable future. When we cook, heat, wash, and conduct our other daily activities with energy that comes directly from nature, we inform and hearten our relationships with the earth and one another. This is truly power to the people. Solar communities are intergenerationally kind; they take nothing from future generations and leave no toxic waste behind.

Amaterasu, the goddess of the sun, is the most well-known deity in Japanese mythology. After a battle with her brother Susano'o, the god of storms and the sea, she fled and hid in a cave, and darkness covered the world. All the other gods and goddesses tried to coax Amaterasu out of her cave, but she remained there until she saw a ray of dawn in a mirror and, dazzled by her own light, came out. Surrounded by the other gods, including the god of merriment, her depression lifted, and she returned her light to the world. I pray that the sun goddess Amaterasu will guide us from our fear-based industrialism and our efforts to vanquish the natural world to a civilization grounded in love and compassion. As a meditator living a Buddhist life, I renew my bodhisattva vow to save all sentient beings every day. I know that compassion and creativity can bring transformation and salvation.

My life and Japan's history reflect both the brilliance and the shadows of modernity, and both have led to our current impasse. I have been an environmental and peace activist for decades, mostly in the US but also in Japan and elsewhere, and I believe we are on the edge of a cliff, standing on a precipice between global disaster on one side and a paradigm shift that can lead to immensely positive transformation on the other. The outcome is up to us. I am grateful to be alive with you at this time.

This book is a wake-up call,
A call to young people,
A call for hope and action.
Are you listening?
The grandmothers are with us.

Mayumi Oda
Gingerhill Farm
Kealakeakua, Hawai'i
Summer 2019

Sarasvati's Gift

CHAPTER I

My Story Begins

I WAS BORN IN 1941, just months before the Japanese bombing of Pearl Harbor, Hawai'i—not too far from where I now live. I was born into the fire of war, so my own history is deeply connected to Japan's history. They are both reflections of modernization and the fallout of industrialization, and they echo the events that have led to our current situation here on Earth. When I think about our planet's history to this present moment, I believe we are on the brink of disaster and simultaneously on the cusp of positive transformation.

The last feudal Japanese military government, the Tokugawa shogunate (1600–1868), closed Japan's doors to the outside world to prevent Christianity from colonizing Japan's spirituality. They worried, perhaps correctly, that the one God of Abraham and Jesus was a threat to our eight hundred thousand Shinto gods. For 268 years, Japan had lived sustainably, utilizing its limited resources by fishing, farming, and recycling materials to support a peaceful, waste-free society. This lifestyle pervaded all aspects of life— cultural fertility, high art, and grounded spirituality.

In 1868, Emperor Meiji moved the capital from Kyoto to Tokyo and centralized power from the regional lords to himself. Over the next sixty years, Japan entered the modern world, embracing free-market capitalism modeled after England and North America. This so-called Meiji Restoration and its industrialization received powerful support from the Tosa, Satsuma, and Choshu clans, which merged into the powerful, pro-empire Satchō Alliance and fully embraced Western dress, lifestyle, and industry.

By the end of the nineteenth century, huge business conglomerates called *zaibatsu*—including Mitsubishi, Mitsui, and Sumitomo, among others— materialized. These zaibatsu fueled the industrial revolution while Japan's political leaders developed a strong military, all in the name of modern-

ization. The country needed coal, iron ore, and other materials to build railroads, shipyards, munitions factories, mines, and textile manufacturing plants. However, these were resources that weren't available in Japan. So, Japan went to war to obtain them.

A new law required all healthy young men to be drafted, and draftees were sent to the Sino-Japanese War in 1894 and the Russo-Japanese War in 1904 to 1905. Victories in China and Russia allowed Japan to build the South Manchuria Railway in 1906, which supported the transport of resources to fuel Japan's modern economy.

By the outset of World War I, Japan had become a major industrial nation. In 1930, Japan invaded China again, and in late 1937, over a period of six weeks, Imperial Japanese forces murdered and raped hundreds of thousands of residents of Nanjing, the capital of the Republic of China. Japan's government still denies guilt for this shameful episode.

My Parents and Grandparents

My paternal great-grandfather, Goichi Oda, a disrobed priest, traveled on the Sea of Japan from Tottori Prefecture to Hokkaido, the northernmost of Japan's islands. There he married my great-grandmother, Hatsu, who was probably Ainu, the indigenous people of Hokkaido. They both died in 1896, when their son, my grandfather, was ten years old. My grandfather, Goichiro Oda, was adopted by a Confucian scholar, and he was trained in philosophy. His education and handsome features opened doors for him, and he was invited to Tokyo to become a soldier in the prestigious Imperial Guard during the Sino-Japanese War.

My paternal grandmother, Ai Oogida, was the daughter of a businessman who owned one of the first dairy farms in Japan. He had come to Kona, Hawai'i, in the 1890s to buy Holstein cows. Unfortunately all the cows got sick in transit to Japan and had to be thrown overboard. As a result, the family business declined, and my grandmother suffered great hardship. To cope, she began practicing Nichiren Buddhism and became a social revolutionary. Eventually she met my grandfather, Goichiro Oda, the soldier-scholar who had by then left the military to become an accountant

and was employed by a big aluminum company. In 1913, she gave birth to my father.

My mother's family—the Hirotos—served as policy advisors to the Tokugawa shogunate for over two hundred fifty years. As a teenager, my mother's father—my grandfather Isshin Hiroto—was chosen to go to the Peers School (originally established to educate the children of Japan's nobility) as a friend of Emperor Taishō. Unfortunately, once, in a playful moment, he accidentally hit the emperor on the head and was expelled. After that, he attended the newly opened University of Foreign Languages, where he was one of the first students to study English and Russian.

It didn't take him long to realize that modernization and militarism benefited only the zaibatsu, and he became discouraged about the direction in which the new ruling class was taking Japan. At the same time, he continued living among the gentry in uptown Tokyo. He met my grandmother, Hana Nemoto, who came from a downtown family of silversmiths. She was a beautiful young woman ready for marriage, and he married her against tradition and his class. They had six daughters and two sons and lived in a sprawling mansion in Tokyo's Hongō district.

My mother, Aya, was their youngest child. Grandfather was determined that she and her sisters not marry into the new ruling class, and so after fifteen generations of prosperity, the Hiroto family fell into decline, beginning with my mother's generation. When my grandparents passed away, my uncle, Jin Hiroto, assumed her guardianship.

In the days preceding World War II, the man who was to become my father, Yasumasa Oda, had been summoned from Kyoto to Tokyo to teach philosophy and history at the Imperial Military Academy. At an arranged-marriage tea party in Tokyo, my uncle was looking over the eligible bachelors and decided this man would make a respectable husband for his sister. She had no say in the matter. My father agreed, and my parents married and moved into a two-story house in a suburb of Tokyo.

I was born there in 1941. Six months later, the Imperial Japanese Navy Air Service bombed Pearl Harbor in Hawai'i, and my country plunged headlong into the war, holding on to its unique sense of spiritual righteousness. On the banner of the Imperial Army were the radiant rays of the

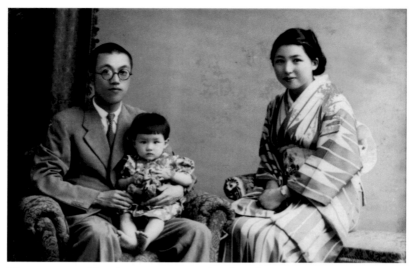

Me at one year old with my parents in Tokyo (1942).

Shinto sun goddess Amaterasu, who according to legend is the ancestor of the emperor and his family.

Bomb Shelter Under the Lotus Pond

When the war began, the Japanese military desperately needed aluminum and other metals to melt for guns, warships, and ammunition; and every family including ours donated pots, pans, and other household items. My militaristic grandfather willingly gave away ornate tea ceremony utensils, flower vases, and other beautiful objects to create material for the Imperial war.

My earliest memories are of tremendous anxiety. I was three years old when my grandfather taught me how to respond to "Who is our friend in Germany?" I'd extend my right arm and salute, "Heil Hitler." When he asked, "Who is our enemy?" I would answer, "Roosevelt." My father and grandfather dug a bomb shelter beneath our lotus pond, and before I was five, the firebombing began. Sirens blared across the city, warning us of air strikes. Sometimes bombs dropped over our town, turning the sky a deep, dark red. I lived in constant fear, expecting a bomb to hit our house.

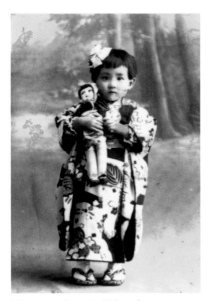

Me at age three in Tokyo for a
Shichi-Go-San (coming of age)
ceremony in a special kimono sewn
by my grandmother (1944).

As soon as we heard the siren, we ran into the shelter and huddled in the dark. I screamed and shook, but nothing could comfort me.

A few months before my fourth birthday, on the night of March 9, 1945, the US Army Air Forces fire-bombed Tokyo. It was the single most destructive bombing raid in human history, greater than Dresden, Hamburg, Hiroshima, or Nagasaki. American B-29 bombers swept over the city like a giant carpet unrolling, incinerating more than two hundred thousand people and displacing a million more. My parents' families lived in Tokyo. As the planes dropped thousands of bombs, my grandfather, grandmother, uncles, aunts, and cousins ran for their lives. One of my aunts described running through a bloody sea trying not to step on dead bodies, watching burned books and papers fall from the sky like autumn leaves. Many of my aunts' houses were lost to the fire, and my family decided it was time for us to evacuate. My mother, my brother Masano, and I moved to Iwate Prefecture on the northeastern coast of Honshu, about three hundred miles from Tokyo, where one of my aunts had already relocated. My grandparents and my father stayed behind to protect our house.

We arrived in Iwate on the spring equinox to the full blossoming of apple, cherry, and plum trees. The green mountains and flowing rivers were a welcome refuge from the horrors of the war, especially for Mother, who worried all the time about her children and in-laws when we had been in Tokyo. Living away from the burdens of war, she was finally happy. That summer, the government forced her to dig pine roots, which they used to make oil for fighter planes. Even in the intense heat of August, using a pick

and constantly wiping the sweat off her brow, she was content. I always went with her and watched her dig the pungent roots, and I visualized the fighter planes being fueled with their oil. This is the happiest memory of my childhood.

On August 6, 1945, the atomic bomb was dropped on Hiroshima, killing seventy thousand civilians. Three days later, another atomic bomb devastated Nagasaki, taking forty-five thousand more lives. The next week, our neighbors gathered on the grounds of a temple to listen to the emperor's broadcast—the first time the Japanese people had ever heard his voice. He announced that Japan had lost the war. The adults broke down crying. I was happy, relieved the war was finally over.

Feisty Like Ai

Not long after the announcement, my father bought train tickets so we could all return to Tokyo. For the late-night journey, we had cans of sesame crackers to eat and an empty bottle to pee into. The train was packed with people sitting on benches, on the floor, and some even hanging from the train outside. It was impossible to move, and I sat on my father's lap, gazing out the window. I watched stars stream by as we rushed along the tracks, wheels clattering across bridges over rivers, the smokestack whistling into the Milky Way. We were going home!

Arriving in Tokyo at dawn, we found a city in ruins. Nothing was left but the metal frames of buildings hanging like scorched black bones. We reached our house in the suburbs and were relieved to discover everything intact. We were so happy to reunite with my grandparents, but that happiness was short-lived.

The military had lost its funding and power with the war, so my father lost his job as a professor at the military academy. Though our house was undamaged, the land was devastated, and the remains of war were everywhere. The life we'd known had vanished. Grandfather, who had strongly believed Japan would be victorious, was heartsick. Food was scarce; we had nothing to eat but sweet potatoes. Money was useless; there was nothing to buy. We struggled to survive for two to three years.

My grandparents tried planting a vegetable garden, but they weren't good farmers. It fell to my mother to feed the family. Out of desperation, she took her dowry of beautiful silk kimonos that she loved dearly and exchanged them for food. She and I rode on the train to the countryside, and I watched as she traded her favorite tie-dyed kimono for rice. (It had a pattern of peonies, and she'd wanted me to wear it when I grew up.) When we found a farmer who could spare some rice, Mother filled a huge sack and carried it home, and our family devoured it. The next day, the search for food would begin again.

I watched Mother give up everything to feed our family. I was just four years old, and I gathered my courage and asked Grandfather's second wife, Hisayo, why she wasn't giving up anything—she had jewels and many other beautiful things—to trade for food. Enraged by my insolence, she filled our iron bathtub with cold water, threw me in the tub, covered it with a lid, and sat on it so I couldn't get out. I screamed, my face only barely above the water. My grandmother kept demanding I apologize, but I wouldn't. Nothing my mother did could stop my grandparents from punishing me.

My family said I resembled Grandfather's first wife, my biological grandmother, Ai. They didn't want me to end up like her. Ai was outspoken at a time when women were expected to be silent and subservient. Deeply compassionate, she caught tuberculosis while caring for the sick and was sent to a sanitarium. She was a Nichiren revolutionary, and when some of her friends were sent to prison for inciting revolution, she took rat poison and ended her life, worried she might be in danger and concerned for her husband's career and reputation.

My mother could barely feed the family, and she couldn't protect her children. In the aftermath of war, violence had entered our home. We had very little left, and my mother couldn't stand living with violence and poverty any longer. One afternoon, with the last of her money, she bought my brother and me sweet-potato candies and told us, "We're leaving." Carrying my brother on her back, she took my hand and we walked to the nearby railway crossing, with Mount Fuji looming in the distance. We stood on the edge of the tracks and suddenly my mother squeezed our hands. I saw the wheels of the train barreling toward us and screamed, "Mother, don't

die!" In that moment, she awoke from her trance and didn't pull us onto the tracks.

Dragon Spirit

Three years later, when my little sister Hiromi was less than a year old, my thirty-two-year-old mother caught typhoid fever and was hospitalized. Ambulance drivers in white uniforms came to our house, put her on a stretcher, and drove her away to be quarantined. My baby sister was still breastfeeding, so Grandmother offered her dry breast to suckle before feeding my sister bottled soy milk. My brother and I were sent to live with our great-aunt Mitsu. She'd left Tokyo during the carpet-bombing and was living in the old farmhouse of a horse breeder. There were sumi-e, or ink-wash paintings, of horses on the shoji screens of the sliding doors.

When we arrived, Mitsu told us that the spirit of a dragon lived in the marsh downhill from the farm and that if we weren't good, the spirit would pull us into the water. There was a deep well with a wooden bucket on a rope near the house. One day, while pulling the bucket up from the well, my great-aunt told me about Ai dying at age thirty-two. She said she didn't want my mother to die that way too. In Japan, it's believed that women fall under a spell when they're thirty-two. She and I prayed to the dragon spirit for Mother's recovery. A month later, my mother returned from the hospital. She was emaciated from being sick, but we were so happy she was back. Over time she regained her strength, and by the time I entered primary school, I was back living at home and Mother was well enough to make me a backpack embroidered with colorful thread.

Although our grandparents had been unable to grow food after the war, after trials and with diligence, they eventually became good farmers. In summers, their garden produced eggplants, cucumbers, and tomatoes. In autumn, the trees were laden with pears and persimmons, and chestnuts fell into our yard from next door.

Mother's Compassion

I had started drawing when I was just three years old. After the war, paper was scarce, so I drew on whatever I could find. I recently discovered a drawing I'd made of a little girl in a beautifully patterned kimono standing with a basketful of fruit, carrots, daikon, and turnips. A bird is flying overhead, and an ant is crawling on the ground. I'd painted it on the back of a page of my father's manuscript. It's not much different from the way I paint now! My mother thought it was important for me to draw, so she eventually managed to save the money to buy me paper and crayons. I wanted to make a book of drawings when I grew up to make Mother happy. That was my dream.

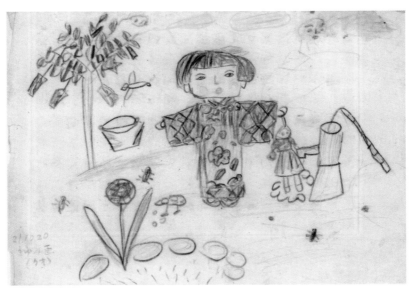

One of my early drawings, done at age seven in Tokyo (1948).

My family sold our small organ to buy a sewing machine, so Mother could make our clothes. And as a special food treat, she made fluffy donuts. She mixed sugar, flour, and precious eggs, then deep-fried the batter in amber-colored oil in our wok as we watched golden rings puff up, emitting

the sweetest smell. When I took a bite, I felt like I was eating the whole universe. I was so happy. Things in our family were beginning to turn around.

When my youngest brother, Masayuki, was born, Grandmother sewed a little kimono for him to wear as we celebrated his new life at the village shrine. He was cute and plump like a Kewpie doll. When Mother nursed him, she looked like Quan Yin, the Buddhist goddess of compassion, with full breasts. As we gathered around, we smelled the warm milk and felt nourished. We were finally healing from the ravages of war.

My Buddhist Upbringing

My family was devoted to Nichiren Buddhism. Nichiren, a thirteenth-century Japanese priest, concluded that the highest teachings of the Buddha are found in the *Scripture of the Lotus Blossom of the Sublime Dharma*. Nichiren Buddhists express their devotion by chanting *Namu-Myōhō-Renge-Kyō* (Homage to the *Lotus Sutra*). The main teaching is that all beings have the potential to become buddhas, awakened to reality as it is.

My father practiced Zen as a student at Kyoto University and studied Buddhist philosophy with Professor Kitaro Nishida, founder of the well-known Kyoto school. Father emphasized that we ourselves are buddhas. "On heaven and earth, we are the world-honored ones," he would say. According to legend, these were the newborn Buddha's first words, and it was my father's favorite saying. He wanted us to respect ourselves and not harm others, and he taught us how to concentrate on the moment. As part of our family practice, I chanted mantras with my grandparents every morning and evening.

Miss Tarzan

My grandmother would scold me for not behaving like a girl. She and Grandfather were old-fashioned in their thinking. I envied boys—they had so much freedom. I saw my first movie in a burned-out theater my aunt had just opened in Asakusa in downtown Tokyo: *Tarzan: The Ape Man*, with Johnny Weissmuller swinging from a vine and shouting wildly into

the vast jungle. During lunch break at school, dreaming of Tarzan, I'd climb onto the roof (and then get severely punished). And on my way home from school, to prove I was as good as a boy, I peed standing up. My classmates told on me and I was forced to stand in the school hallway for a long time as punishment. "You are a girl. You shouldn't do that," they said. Even my mother would admonish me, explaining, "Girls should help their mothers in the kitchen."

In 1954, I entered an all-girls high school. We wore blue uniforms with white socks. Most of the girls dreamed of getting married and having families, but my best friend, Kazuko Kuroda, and I were different. Her brother, Kan'ichi Kuroda, was a leader of the *Zengakuren* league of students, noted for organizing marches and protests, and we learned all we could from him. He gave us a list of books to read, such as Simone de Beauvoir's *The Second Sex*, and Kazuko and I felt it spoke for us. We skipped school to see New Wave French films by Jean-Luc Godard and others. I even asked Mother to make me a black trench coat to wear over my blue school uniform, so I would look avant-garde, like the French.

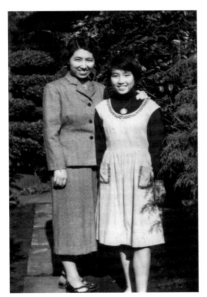

Me at age eighteen with my mother in front of our home in Tokyo, wearing a dress she made for me (1959).

The 1960s brought student revolution in reaction to postwar resentment and the lack of democracy in Japan, and my friends were passionately involved in radical politics. Kazuko followed her brother and became a revolutionary, leading a major student strike. Activists organized against the renewal of the Japan-US Treaty of Mutual Cooperation and Security (also known in Japan as ANPO for short). Because ANPO supported the use of nuclear arms and represented US military control of Japan, there were massive protests all over Japan.

Students, labor unions, writers, and artists united to demand equality, human rights, and the return of power to the people. In Japan, this was the time of *zen kyōtō*, "We fight together!" While all this was going on, I focused on my studies to prepare for university entrance exams, and in 1962, I was accepted into Tokyo University of the Fine Arts in the crafts department to study design and fabric dyeing.

Ticket to Freedom

When I was a freshman at the university, I met John Nathan, a brilliant American Harvard grad who taught English literature at Tsuda Women's College. We met at a student conference in a botanical garden in downtown Tokyo. It was a rainy afternoon, and John was wearing an enormous khaki raincoat purchased from an army surplus store. He walked over to me and said in fluent Japanese, "*Ai gasa desu*" (Here we are in love, under the umbrella together).

I looked up at him, towering above me at six foot three, surprised by his stature, what he said, and how he said it. He said he was Jewish; I had no idea what that meant. We walked through the garden, talking easily. For the first time, I felt I'd met someone who really understood me. After that, we met in jazz coffee shops and talked about Japanese culture, art, and literature for hours on end, while listening to Thelonious Monk, John Coltrane, and Miles Davis. John was a saxophone player and liked "Take Five" by Dave Brubeck.

John bought a Honda motorcycle, and I'd sit behind him, riding all over Tokyo, he in his white helmet and I in my red helmet. I felt so free with him, and he didn't see anything wrong with my freedom. I knew he held the ticket for my liberation as a Japanese woman. After two months of dating, John asked my father for my hand in marriage. Hearing this, my mother started to cry and said to my father, "I like John; it's just that foreigners . . ." she paused, searching for the words, "make my skin crawl." Father said it was my decision whether or not to marry John.

The US ambassador to Japan at the time, Edwin O. Reischauer (appointed by President John F. Kennedy), had been John's professor at

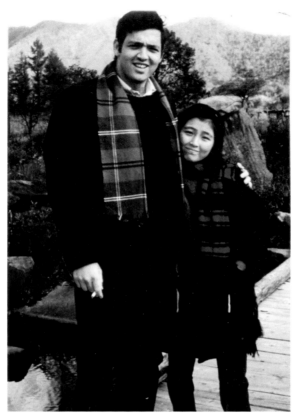

John and I on our honeymoon in Europe before moving
to America (1966).

Harvard and recommended John for a professorship in Japan. The ambassador invited my parents to tea at the American Embassy and told them, "It's important that these two get married." My mother, who was concerned that marrying John would prevent me from finishing university, felt reassured by Ambassador Reischauer's words.

In October 1962, four months after we met, we had a small, traditional Shinto wedding at the old Akasaka Prince Hotel in Tokyo. A big typhoon hit that morning, bringing torrential rains. The only formal suit John could find for his large frame was from a rental shop for sumo wrestlers, and the pants were three times bigger than his waist. John's parents sent me a

Navajo squash-blossom necklace for fertility, which I wore with my simple, white wedding dress. My mother, still concerned about me marrying a foreigner, fainted during the ceremony from a high blood pressure spike. For our honeymoon, we traveled by train to the beautiful Fukushima region. While looking at the green mountains and watching autumn leaves floating down, suspended in air, then landing in the persimmon orchards, I sang my favorite folk song:

> A shrike is crying on a withered branch.
> I am pounding straw.
> Grandmother turns the spinning wheel.
> The water wheel drips and splashes.
> All is the same as last year.
> But something's missing: The sound of my brother
> splitting firewood.
> My brother has gone to Manchuria.
> Tears gleaming on his rifle barrel.
> Cry away, little shrike, it's so cold.
> Brother is even colder.

As I write this, I remember the fruit orchards and vegetable gardens of Fukushima vividly, and I despair that there has been no farming there since the 2011 Fukushima Daiichi Nuclear Power Plant disaster.

Early Marriage to the Brilliant American Translator

After we married, John and I lived together with my family in Kyodo, a suburb of Tokyo. There were nine of us in the house: my grandparents, parents, two brothers, one sister, John, and me. Father tutored John at night to help him prepare for the entrance examination to Tokyo University. At the time, my father was leading a project to design the *kanji tenkan* system for computerizing Japanese writing. He worked on it for twenty-five years, leading a department of fifty people to realize this great task, and he was awarded the highest honor a government official in Japan can receive from

the emperor. Father had also been invited to become the head of the Japanese collection at the Harvard-Yenching Library. He had to decline the job offer in order to take care of his parents, so having a student from Harvard to tutor was a special pleasure for him.

John was accepted as a regular student, which was unheard of for a foreigner in those days. Our universities were near each other, and John drove us across the city on his motorcycle every day to attend classes. He studied classical Japanese literature and translated modern novels from Japanese into English. He was a gifted writer, and his translations were so brilliant he became the translator for Yukio Mishima, one of the most prominent Japanese writers of the twentieth century.

When I met Mishima, he spoke in an unusually loud voice, clear and articulate, looking extremely dignified. His energy was quite animated. As a young university student, I felt overwhelmed by the presence of this seemingly perfect man. His wife, Yoko, was taking lessons in French cuisine from a chef at the Dai-ichi Hotel, and dinner at his home was served as though we were at an elegant French restaurant, starting with escargot and finishing with crepes suzette flambé. The waiter who poured the brandy on the crepes and lit them wore a black suit with white gloves. After dinner, the men went to the third floor of a tower to smoke cigars, while the women sat at a round table downstairs enjoying coffee and genteel conversation.

Mishima's white stucco, Spanish-style home looked like a Hollywood movie set amid the urban life that surrounded it. We attended parties there and were introduced to prominent writers, including Kenzaburō Ōe, Kōbō Abe, and others in the *bundan*, a community of writers, playwrights, and publishers that exerted considerable influence on Japanese intellectual society.

At one of Mishima's parties, we met the new Time Life bureau chief, Jerrold Schecter, and his wife, Leona. Jerry hired John to work part-time filing human-interest stories about Japanese culture and tradition. Through my association with the Schecters, including Leona's mother who owned a resort in the Catskills, I had the opportunity to learn about Jewish culture and cooking. Leona's mother taught me how to make chopped liver, blintzes, borscht, and even pickled tongue.

The Mishima house was so different from Japanese spaces I was familiar with that I always felt relieved when we returned home afterward. When I told my parents about these parties and Mishima's dignity, Mother wanted me to become a professional and feel comfortable in settings like that. She made us promise I would graduate from college. I majored in fabric design and dyeing, because I loved the beautiful *kosode* robes and Noh costumes from the Momoyama and Edo periods. The rest of the curriculum held little interest for me. I felt more exhilarated by spending time with John and other brilliant people than by copying lifeless old scrolls and stilted Buddhist flower patterns.

I would often skip classes and go to the Tokyo National Museum next door to the university to see works of the great artists. I especially appreciated Tawaraya Sōtatsu, Hon'ami Kōetsu, and Ogata Kōrin of the Rinpa school. I could feel the vitality emanating from their paintings and designs on folding screens, pottery, and lacquerware. Later, I realized that devoting so much time to studying the sensibility of Muromachi and Edo period design at such a young age allowed me to develop an essential understanding of the essence of classical Japanese art.

At this time, John was getting well known for his excellent, eloquent Japanese and started his own radio show at Nippon Hōsō Kyōkai (NHK), the national broadcasting station. He also got an acting role, opposite the famous actress Yaeko Mizutani, in the traditional Shimpa theater. He played Townsend Harris, the first Western consul to reside in Japan who helped shape the course of Japanese-Western relations.

When John was asked by Barney Rosset of Grove Press in New York to translate Kenzaburō Ōe's new novel, *A Personal Matter*, he accepted the assignment. John felt Ōe was an important young novelist and that this was a great opportunity to introduce him to the world. Also, Barney paid a generous advance for the royalties. In 1994, Kenzaburō Ōe won the Nobel Prize in Literature. Kenzaburō, John, and Barney all went to Sweden to receive the award.

John had declined to translate Mishima's novel *Silk and Insight*. When Mishima did not win the Nobel Prize, he was extremely disappointed and redirected his passions and energies into forming a coup d'état, which led

to his eventual suicide by *seppuku* (ritual suicide by disembowelment). He had a deep belief in reincarnation.

Years later, when we founded our Toyouke No Mori farm in Nara, I discovered that the temple in which Mishima wrote *The Sea of Fertility*, which he considered his life's work, was directly adjacent to our farm.

Benzaiten with Two Dragons

60 x 117 inches, 1997

Sarasvati is a river goddess in India. In Japan, we call her Benten or Benzaiten. Originally she was the goddess of art, music, and poetry, and later she also became the goddess of learning.

She came to Japan, in tandem with Buddhism, around the eighth century and became an especially popular goddess with the Shugendo, the mountain shamans. As a river goddess, her energy flows from high to low, like money, so she also became the goddess of commerce and the protector of merchants, to help them conduct ethical business. Musicians and healers paid homage to her too.

Sarasvati has been my favorite deity since my childhood, because she was so directly understandable to a child. I visited many shrines of Sarasvati with my family. I especially liked the one on Enoshima, a small island near Tokyo where we'd sometimes spend the summer.

This Sarasvati wears a crown of a white coiled serpent. The two dragons behind her hold the three treasures of Buddhism: Buddha, Dharma, and Sangha.

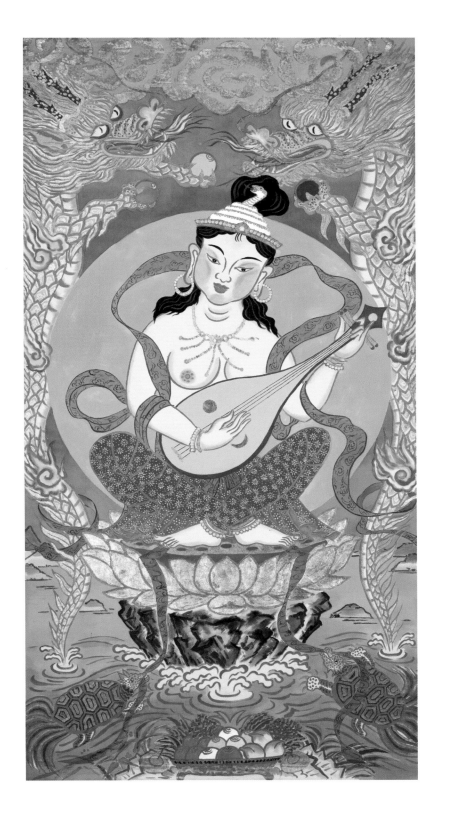

Hariti

48 x 103 inches, 1990

Hariti, also called Kishimojin, was an ogre and the wife of a wealthy merchant who lived in Buddha's time. She was thought to have eaten about five hundred children.

According to legend, Buddha took Hariti's child and hid him from her. Losing her own child, she realized what she had done and felt remorseful.

To quench her thirst for the flesh of children, Buddha gave her the pomegranate, which resembled the taste of flesh. Each morsel of the pomegranate reminded her of the sin she had committed. Hariti became the guardian of children with disease, particularly protecting them from the smallpox plague.

During the time that I was painting this thangka, I lived with Mushim Patricia Ikeda, a practitioner of Korean Zen. Her child Joshua was born at my house. Many mornings we sat zazen together and chanted "Great Compassion Dharani" in Korean for purification, healing, and protection.

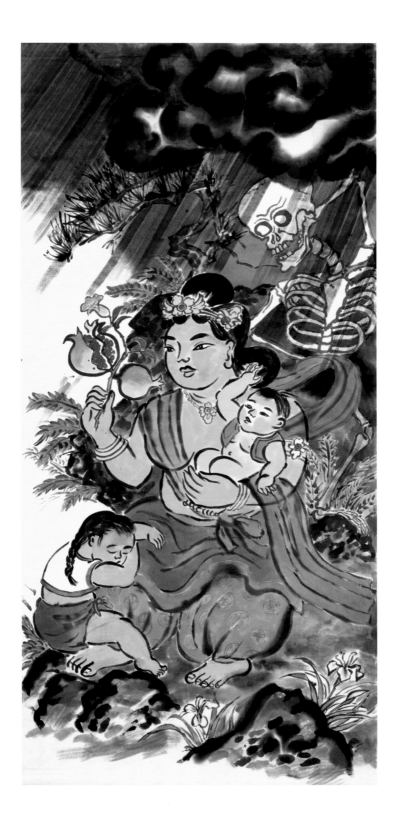

Kannon on the Carp

48 x 108 inches, 1996

My beautiful mother resembled Quan Yin. She was a big, ample woman with fair skin, thick black hair, unusually big eyes, and a beautifully shaped nose.

Right after World War II, it was a very hard time for our family. She made all the clothes for us children. She served my rigid grandparents and made delicious food. It wasn't easy, but she tried to make a good life possible for us. She made everything—the dresses, the food—with such creativity.

To me, the image of Quan Yin is my mother herself. I feel very fortunate to have been raised by my mother.

In a quiet night ocean, Quan Yin appears inside the full moon, in front of us. She walks out of the moon, and while she walks toward us, the moon turns from full to nimbus. She pours forth light toward us and heals our bodies while we sit in lotus at the ocean.

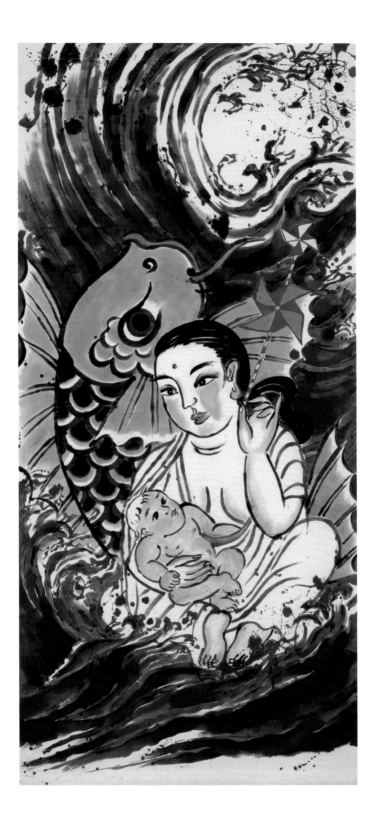

Green Tara with Dragon

60 x 115 inches, 1996

I have been told that Green Tara was born from Avalokiteshvara's tears. So, I painted Green Tara holding two peonies, which are shedding tears. She sits with a green dragon, who is the guardian of Dharma. Traditionally dragons are depicted as quite fierce, but I wanted this dragon to be more playful, licking her feet like a puppy.

She sits in a half lotus with one leg already moving forward, to get ready for action. She's not fully in meditation—she's ready to get up to save all of us from suffering.

Tara is a compassionate goddess, the mother of all Buddhas. When you chant Tara's mantra, Tara comes to you.

When I finished this Green Tara, I was told by a Tibetan lama that by painting the eyes in the hands and the feet, I was painting White Tara—who has seven eyes, including in the hands and feet, and one in the center of the forehead.

So, next I began to paint White Tara, who is more exalted than Green Tara.

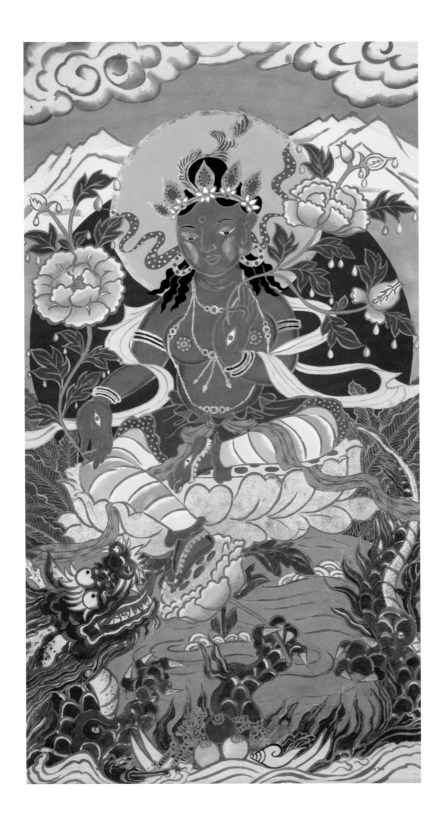

White Tara as Dharma Daughter

36 x 74 inches, 2010

I painted this White Tara for myself. My parents gave me the name Mayumi. The Chinese character means "sandalwood," from which incense is made, and so it is regarded as a Buddhist tree. They used to make bows from sandalwood. So, I was supposed to be strong and supple as the bow. It was my parents' hope for me to become a dharma daughter.

This painting is also a tribute to Atisha, a prince from Bengal who brought the teaching of Tara as the mother of all Buddhas to Tibet. Before traveling to Tibet to teach, Atisha was told that, because of the harsh life in the cold high Tibetan plateau, his life would be shortened by twenty years if he went there. But this didn't sway him from making the journey.

His sacrifice for the teaching of Tara made me realize that in order to achieve enlightenment, Buddhists really do sacrifice themselves. Reading the story of Atisha's life made me want to know more about the Tara teaching. She has become for me an inspiration of great teaching and great action.

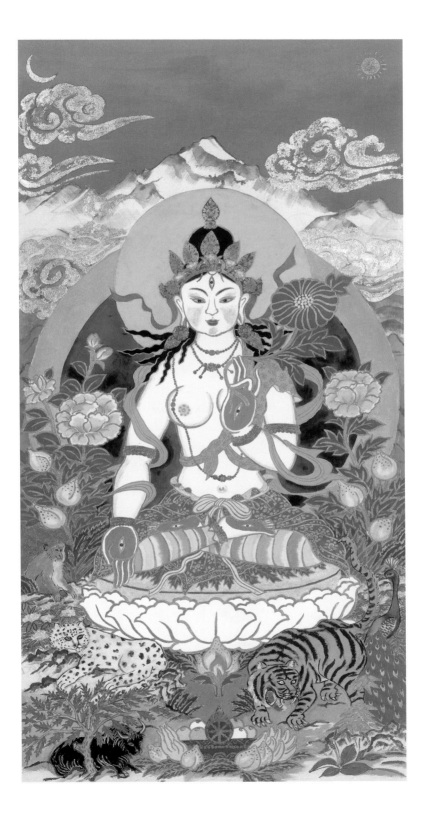

Madonna

48 x 95 inches, 1987

When I visited Venice, Italy, in 1990 for my *One-Woman Show* at Centro Internazionale della Grafica, I saw all kinds of Madonna sculptures, paintings, and mosaics. Gazing at her, I realized that Madonna came from the Egyptian, Greek, and Roman traditions of worshipping the maternal goddess Isis, a tradition that existed before Christianity. Isis is often depicted holding her son, Horus, in the same way that Madonna holds the baby Jesus.

The feminine part of Christianity is expressed through Madonna, but many of the depictions show her as pale, emaciated, and sad. I learned that Madonna, together with Mary Magdalene, were practitioners of the Isis tradition. And since she is a Semite, she would be dark-skinned.

I really wanted to paint a dark, healthy mother of compassion, to bring her back in a way that reflected my way of seeing her. Learning more about the Isis tradition has led me to believe that the true teachings of Jesus may come from it.

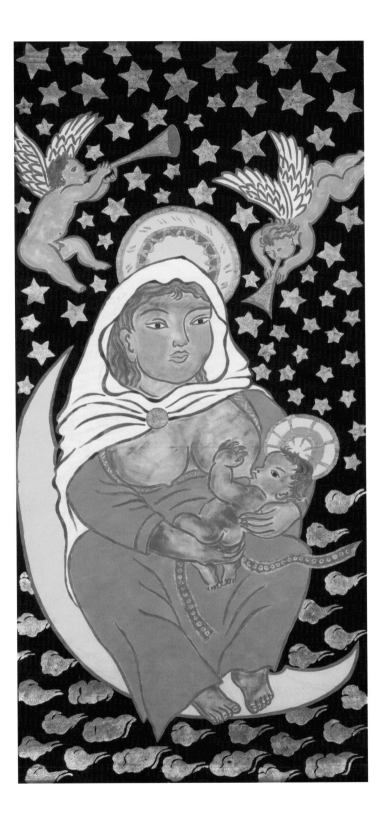

Christa

60 x 134 inches, 1991

In order to secure oil from the Middle East, the United States reacted to the Iraqi invasion of Kuwait by launching the Persian Gulf War in 1990 under George H. W. Bush. It was during the Gulf War that the military started using war machines—tanks, guns, and bullets—made of depleted uranium. This is when I realized that all wars were simply about securing access to power sources.

Later, Gulf War syndrome was identified—a chronic and multisymptomatic disorder involving cancer, liver disease, fatigue, headaches, skin and respiratory problems, and reproductive health problems. The syndrome affected and continues to affect servicemen and servicewomen and civilians from various countries involved in the war. Many children were born with birth defects in the area where the war was fought.

I felt this war symbolized the crucifixion of the feminine life force. The question "Who sacrificed the feminine?" came to me.

I painted the goddess Christa. The creation of *Christa* was a pivotal point in my journey as an artist. Upon finishing this piece, I felt that I had freed myself to come out of the studio and enter the world as an activist.

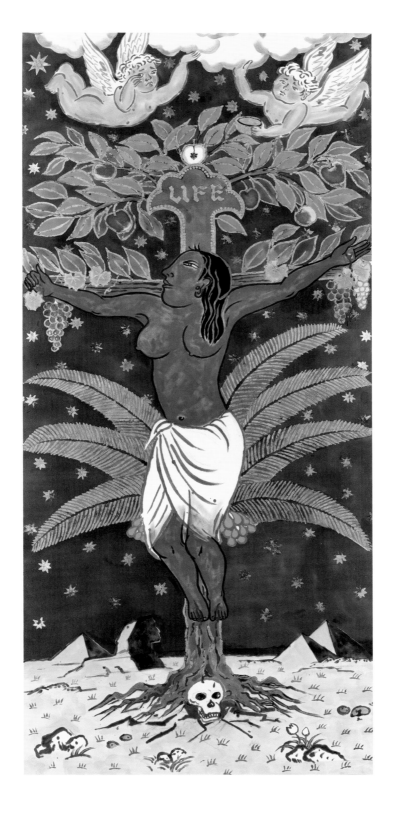

Niutsu Goddess

60 x 115 inches, 2011

The Niutsu were a tribe that lived in the region where Saint Kōbō-Daishi (Kūkai) built the Shingon temple in Koyasan, in ninth-century Japan. They were most likely descended from Korea, probably worked with gold, and were extremely wealthy.

They became patrons of the Tantric teachings of Shingon Buddhism. In Tantric Buddhism, there's no judgment and neither bad nor good. Instead, the goal is to pacify anger, desire, and delusion.

My painting of Niutsu depicts a vision described by Hamamoto Matsuzo, a visionary in the 1950s who imagined Niutsu as a savior of modern Japan. She is a red deity, riding on a mule and crossing over a river where a volcano is erupting. I was imagining a time when a lot of eruptions were occurring—a time when the earth was angry. A braided straw rope, or *shimenawa*, hangs above her head. It traditionally defines a sacred space (*kekkai*), or the territory of the gods. It is similar to the *kapu* in Hawai'i. Kapu defines a space that is off-limits, sacred, and needs to be treated with respect.

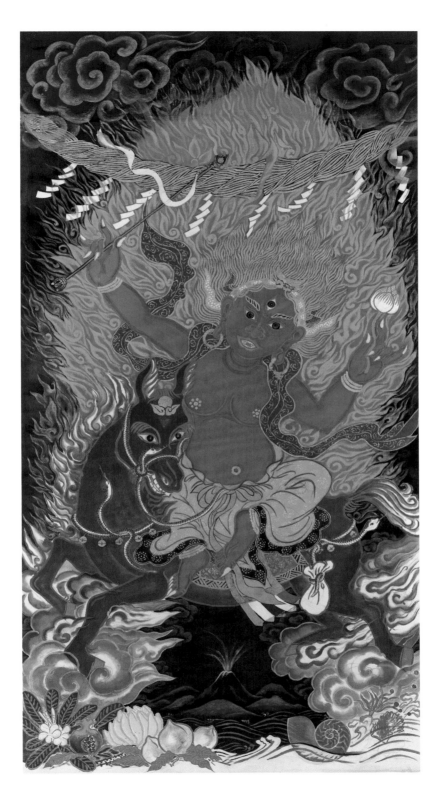

Entering an Unknown World

I
N 1963, President John F. Kennedy was assassinated, and America entered a revolutionary period. The civil rights movement—the effort, led by Dr. Martin Luther King Jr. and others, to secure basic rights for African Americans and to unite all Americans in a vision of ending racism—was gaining momentum. The Vietnam War was escalating, creating a huge divide in the United States. The government instituted a draft, and many young men stayed in college or fled the country to avoid being called to fight a war they did not believe in.

John felt he needed a student deferment so that he wouldn't be drafted. He applied to Columbia University and was accepted as a doctoral student in Japanese literature. We had both finished our university studies in Japan, as we had promised my mother, and prepared to move to America.

We left Japan on a freighter in May of 1966, heading for Siberia on the first leg of a long journey through the Soviet Union and Europe. I wore a yellow summer suit my mother had made for me as I stood on the deck leaning against my big American husband, saying goodbye to friends and family. I felt like a canary chick leaving the nest, entering an unknown world.

Beginning my career as a professional artist in Tokyo (1966). Photo by Ushio Katsuhiko.

We spent two months on trains traveling across Siberia and Europe. When we arrived in New York, Barney Rosset and his wife, Christina, welcomed us to their town house in Greenwich Village. We strolled around Washington Square Park and listened to young people sitting on benches and around the fountain playing Bob Dylan and Joan Baez songs. It was a dream world.

Grove Press, Barney's publishing house, published controversial books such as *Tropic of Cancer*, *The Story of O*, and *The Autobiography of Malcolm X*. Barney relished and promoted original pornographic literature and revolutionary thought. To help support our life in New York, he assigned John a monthly column in the *Evergreen Review* called "Notes from the Underground." John reported on the antiwar and civil rights movements and supported sexual liberation and legalizing abortion. To investigate these strata of society, John and I spent time with Barney and Christina Rosset attending wild parties with artists, musicians, and writers in New York. We careened around the city in their Austin Mini Cooper and on weekends drove to East Hampton, where I met more artists and writers I'd heard about, including Mark Rothko, Willem de Kooning, Andy Warhol, and Jackson Pollock's widow, Lee Krasner. We watched Warhol films for hours, attended crazy concerts by Tiny Tim, and would often be at the Village Vanguard jazz club in Greenwich Village owned by Max Gordon, listening till the early morning hours to great jazz with the amazing performers we had always loved, especially Thelonious Monk, John Coltrane, and Miles Davis.

A Primal Strength

The more the US became involved in Vietnam, the larger the antiwar movement grew. John and I took part in an antiwar march from Central Park to the United Nations, singing "We Shall Overcome" with tens of thousands of others, many wearing tie-dye clothing and bell-bottomed jeans and carrying peace signs. Marching in solidarity, we were part of a huge tide sweeping over America that would change my life and the world forever.

In 1967, my body transformed—my shape changed, and my breasts enlarged. I was pregnant. In October I gave birth to our first son, Zachary Taro Nathan, at Mount Sinai Hospital in New York. Having lived through a war and witnessed the slaughter of so many soldiers, I found it difficult to have a boy, knowing that young men were again being drafted, this time to fight in Vietnam. I was afraid my son might have to become a soldier one day. Kenzaburō Ōe, whose book John was translating, sent us this poem for Zach's birth:

> Boy child born in a time of war.
> May you flourish and thrive.

Going through natural childbirth, I felt a primal strength I'd never experienced before. I was studying printmaking at Pratt Institute, and I began creating images of full-bodied women with large breasts. I titled my first etching *The Birth of Venus*. Much later I learned these figures resembled Neolithic goddesses carved thousands of years earlier. But the images had emerged from deep inside of me, a place that has been part of women's history for millennia. Through the process of creating each print, I discovered a sense of strength within myself.

In 1968, John was invited to join Harvard University's Society of Fellows, a group of promising young scholars selected by Harvard at the beginning of their careers to conduct independent research. And so we moved from New York to Cambridge, Massachusetts. At the time, Harvard students were on strike, protesting against the Vietnam War. Marijuana and LSD were expanding the minds of students and faculty. Young men were refusing the draft, and people were dropping out of college and moving back to the land.

I attended women's liberation meetings and became part of an underground movement where women expressed things they'd never said before. For hundreds of years, women had been ruled by the tyranny of men, and now we were openly sharing our hopes and fears and the desire for our voices be heard. We questioned the US government and talked about our roles and responsibilities as citizens working for peace. John and I attended

Beauty Descending etching, edition of 30, created in 1968.

performances of the Living Theatre, spent time with Allen Ginsberg chanting *"Hare Krishna,"* and joined love-ins at Harvard Square. We were a part of the countercultural renaissance pulsing to the tune of "Lucy in the Sky with Diamonds."

At the end of 1970, I gave birth to our second son, Jeremiah Jiro Nathan, and we moved to Princeton, where John had been appointed professor of Japanese literature and culture. We lived in an eighteenth-century field-stone house called Jewel Farm, which sat in the middle of a 150-acre soy-

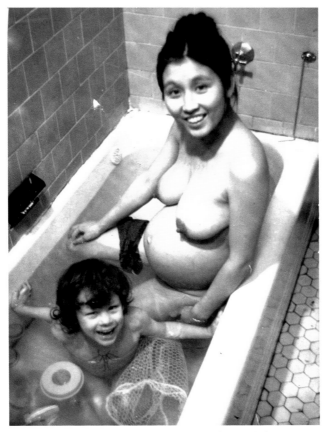

In the bathtub with my son, Zachary, age three, while I was
pregnant with my second son, Jeremiah (1970). Photo by
Hiroshi Teshigahara.

bean field. John hunted ducks on the pond, and we collected honey from
wild beehives we discovered in a small storage shed. Living on the farm
brought back beautiful memories of the time I spent with my mother in
Iwate.

I built a print studio in the attic. As a way of reconnecting with my child-
hood and trying to fill my longing for Japan, I started making silk screens
of women at one with nature. The images flowed through me; each had a
life of its own. I loved Japanese ukiyo-e (the art of the floating world) that

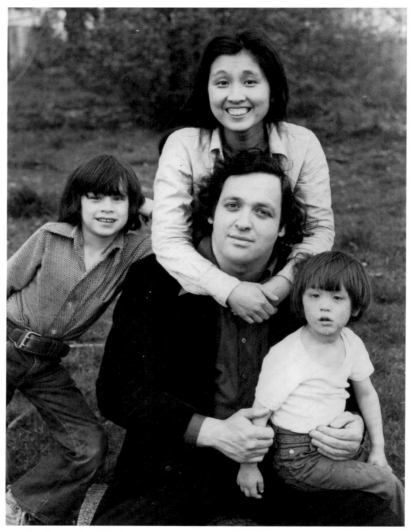

My family—John, Zachary, Jeremiah, and me (1974). Photo by Hiroshi Teshigahara.

often depicted courtesans and goddesses in nature. Using Japanese rice paper, I made large, multicolored silk-screen prints that looked like modern versions of Edo-period ukiyo-e. The prints celebrated goddesses in natural settings—diving into the ocean, frolicking through flower gardens, soaring

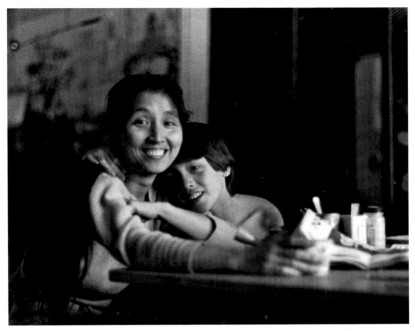

Me with my son Jeremiah at four years old (1974). Photo by John Nathan.

in the sky—that reminded me of my homeland. I loved them, and others loved them too, appreciating that they were both modern and traditional at the same time. I received invitations from museums and galleries to show my work and began to make a living as a professional artist.

The Zen Practice for Me

In the summer of 1978, John, the kids, and I traveled through Europe. In Javea, on the Mediterranean coast of Spain, we stayed in a farmhouse on a small almond orchard. One night after a huge thunderstorm, John and I were sitting outside on wooden chairs when the aurora borealis displayed a stream of spectacular reds. Suddenly I saw a huge cigar-shaped craft hovering above, shining a bright light through small square windows. I had the distinct feeling that someone—something—was watching me. It was the same feeling I'd had when B-29 bombers flew over Tokyo, only this time

I wasn't afraid. I sat staring at what must have been a UFO; I was unable to move. It seemed it had spotted me, and I couldn't hide, because it held a consciousness bigger than anything I'd ever experienced before. I felt as if I was being watched by an all-seeing eye. A few days later when I spoke to John about it, he didn't remember a thing, which I found puzzling.

When we returned to Princeton, I became so ill that my back went out and I couldn't get out of bed for a few months. I was diagnosed with nephritis, inflammation of the kidneys. Later, I learned that becoming seriously ill is common after people encounter UFOs. I was told I might have to undergo dialysis. To avoid this, I started a macrobiotic diet to heal myself. A health-food store had just opened in town, and I bought *The Tassajara Bread Book* by Edward Espe Brown. Every week I would knead whole wheat bread and dream about life at Tassajara Zen Mountain Center and Green Gulch Farm Zen Center in California. John did not enjoy our diet change. As I became healthier, I began to see that a gap was forming between us.

On sabbatical from Princeton, John decided to make a series of documentary films in Japan—a trilogy to be called *The Japanese*. I didn't want to go to Japan, but John said he needed to be with our kids, so reluctantly I went along. I found that the land of my birth had changed drastically. One night I had a vivid dream: I was an oversized tatami mat in a four-and-a-half-mat tearoom, and my mother was stomping on me (as the tatami), trying to get me to fit into a space that was obviously too small for me. I woke up screaming, "It hurts!" and felt profoundly sad. Japan had been a spiritual country, but now people seemed intoxicated by material things. Family farming practices were threatened by rampant corporatization. Large extended families had broken down into nuclear families living fast-paced, urban lives, far from rural or natural living. I was miserable. Japan had changed, and life in America had changed me. It felt as though I no longer fit in either place.

To gain some balance, I started practicing zazen meditation at a Soto Zen temple in Tokyo. But I found it to be oppressively patriarchal. Women couldn't enter the zendo (meditation hall), and the priests were

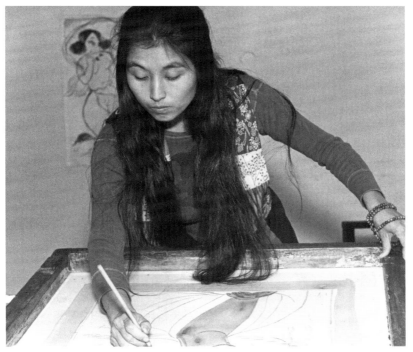

Working at my studio on the third floor of Jewel Farm in Princeton, New Jersey (1972). Photo by Arthur Dresden.

old-fashioned and strict, acting like old samurai. If you fell asleep during meditation, a priest would hit you on the shoulders with a *keisaku*, a long stick. Around that time, I met Richard Baker Roshi, the young abbot of San Francisco Zen Center, who was in Japan to attend the Mountain Seat Ceremony (installing a new abbot) of Yamada Mumon Roshi at Myōshinji Temple in Kyoto. Richard was with a group of American Zen practitioners and invited me to join them.

During World War II, Mumon Roshi had visited many places of war, and what he saw left him with deep feelings of repentance. In 1967, he went on a pilgrimage throughout Southeast Asia to apologize to and say prayers for the war dead. Richard had studied Zen in both San Francisco and Kyoto and was a brilliant, charismatic leader. After the ceremony and a

night of wild disco dancing together, Richard and his colleagues invited me to spend the summer at their farm in California, Green Gulch Farm Zen Center. The following July, my boys and I spent a month at Green Gulch, and I fell in love with the practice, the garden, and the community. It felt like the way I had been raised in Japan, and I remember thinking, "This is the Zen practice for me."

Goddess of the Valley

When my family and I returned to Princeton, a huge shopping center was being built near our town. Once it opened, I went inside and was horrified. In the place of beautiful green fields and farms was the gaudiest mall I had ever seen, with a gigantic Kmart store. I could feel a huge change coming, the beginning of corporatization and a global market economy that would swallow us all up. I dove into Zen practice even more deeply, seeking another way to live.

John and I decided to move to California to mend our relationship and start a new life. My self-search had become most important to me. We rented a house near Green Gulch, so I could walk to zazen every morning.

We started therapy, such as encounter and primal therapy, and spent time in couples' therapy, but in a short time John and I were separated, and he moved to Mill Valley, nearby. John and I kept our friendship, but I realized I just wanted to be myself. We shared custody of our sons. It made me sad that I couldn't keep our family together for my children's sake, but I enjoyed living in the house by Green Gulch with other mothers and children. We helped each other follow the Zen schedule and sometimes even shared meals and childcare, and we took care of one another. Green Gulch Farm Zen Center became my extended family. I spent most of my time painting and working in the garden, slowly healing my difficult past.

While preparing some of my silk screens for a book, I looked at the color plates and realized they were all of goddesses. So, with the encouragement of my first publishers, Lancaster-Miller Publications, we titled the book *Goddesses*. It was well received by many people at the forefront of

the new women's movement. I'd tapped into the collective feminine unconscious that countless women, and men, were seeking—a deep yearning for a return to the values of nurturance, support, and connection.

Not long after that, the house I was living in came up for sale, and I bought it and named it "Goddess of the Valley." I built a Japanese teahouse for meditation and placed a beautiful Nepalese figure of Sarasvati on the altar. When I was growing up in Japan, my cousin and I would go over the mountain from my aunt's house to the Sarasvati shrine, located in Zeniarai Benten (money purifying) cave in Kamakura. Merchants and businesspeople went there to wash their wallets and handbags at a spring inside the cave to cleanse their money and bring prosperity. Pilgrims brought eggs to put in the spring to feed the white snakes that visited the shrine.

On one of our visits, we saw a shaman who drew and told fortunes to earn his alms. He was drawing a picture of a snake, vibrating his brush to make the scale patterns with one stroke. Then he looked up and said to me, "Young girl, you are going to be a successful painter." In that moment I believed that I *could* be a painter and do well in my life. Every year, I continue to visit this shrine.

Deguchi and the World of Goddesses

In 1987, William Irwin Thompson of the Lindisfarne Association invited me to create ten giant goddess banners to bless a conference he was organizing at the Cathedral of St. John the Divine in New York City. The theme of the conference was "Gaia, a Way of Knowing: Political Implications of the New Biology." Scientists, artists, and spiritual seekers joined together to talk about where they found wisdom. I had been a printmaker; I'd never painted before. I was overwhelmed by the size of the cathedral; the nave was 124 feet high. I had to paint ten five-by-ten-feet canvases to hang from the ceiling, and I had no idea how I would do it.

Because of the scale that was needed, I had to work on the floor on my hands and knees, horizontally. I needed a yoga practice to do it. Painting on canvas was a different medium for me, needing incredible precision. To this day, I paint my large thangkas in this way.

Around that time, a friend gave me a lengthy biography of Onisaburo Deguchi, a Shinto revolutionary of the late nineteenth and early twentieth centuries. It would take me three months to paint the banners, and during that time I absorbed the life and writings of Deguchi. He was a spiritual master, a healer, an artist, and a founding teacher of the Oomoto school, a neo-Shinto spirituality movement. He had many mystical experiences and described how miracles happen. Reading Deguchi's biography lets you learn how to manifest your own miracles through the power of prayer. I would paint all day and read about him and his miracles at night. The book gave me the strength to paint the ten goddess banners.

When I finally finished the banners, I collaborated with a stage designer at the cathedral to hang them using a hydraulic jack like people use in warehouses. I spent whole days staring up at the nave ceiling to decide exactly where to position the banners. When we finished, I finally looked straight ahead and saw that right in front of me, sitting in a glass case, was a photograph of Onisaburo Deguchi. The photograph was a gift from the Urasenke tea school; it had accompanied one of Deguchi's very famous tea-bowls that he made while under house arrest. Urasenke had presented it to the Cathedral of St. John's dean, James Parks Morton.

"Oh my God, Deguchi is here with me!" I thought. Then I realized that my purse was gone, along with my passport and credit cards. I recalled that while we were hanging the banners, a young man had walked through the cathedral looking for something. Using Deguchi's technique of creating miracles, I imagined that the young man had stolen my purse, and I started visualizing him. I thought to myself, inside my heart, using a technique called Heart Now, "I will give you the money and the wallet but send me the passport and credit cards."

That night I got a call from a man who had found my passport and credit cards and said he would deliver them to me at the cathedral the next morning. Sure enough, the next day he delivered a bag, which he'd found in a garbage can. Inside I found my hairbrush, my scarf neatly folded, and my credit cards and passport. But I was still missing my address book. Again, using Deguchi's technique, I set the intention that it would be returned

to me. A week later, my address book arrived in the mail without a return address.

Onisaburo Deguchi has since appeared many times in my heart to help me through difficult experiences. He has become my spiritual guardian and taught me the way of the world of goddesses.

Dakini the Sky Walker

60 x 108 inches, 1987

Dakini teachings talk about the need to reflect on our own mind, which is the mysterious home of the Dakinis.

Tibetan Buddhists teach a very simple practice to go deep within our own mind. It is to reflect on all the beings we have been in prior lifetimes: once we were snakes, once we were fish, once we were the monk of a temple, once we were a prostitute. These past lives are all reflected as who we are in this moment. It's basically the same as how Zen Buddhism teaches coexistence. By understanding this deep interconnectedness, you become a "sky walker" in this universe; in both heaven and earth, you have the freedom to walk through, unimpeded.

The Dakini were originally lower-class women who worked on funeral rites, chopping up bodies with cleavers before putting them up on the sky burial platform. So, in this painting the Dakini is holding a cleaver.

This Dakini helps you visualize your body, the symbol of selfhood, being chopped by a cleaver and put into a cauldron made of a skull. The body burns with a cleansing fire and becomes the amrita, or nectar, offered as a practice of complete surrender to Dharma.

She balances with the trident of three skulls, presenting the three poisons of anger, greed, and ignorance.

At a time when I was exploring who I am, the Dakini became a great teacher, and I painted this thangka.

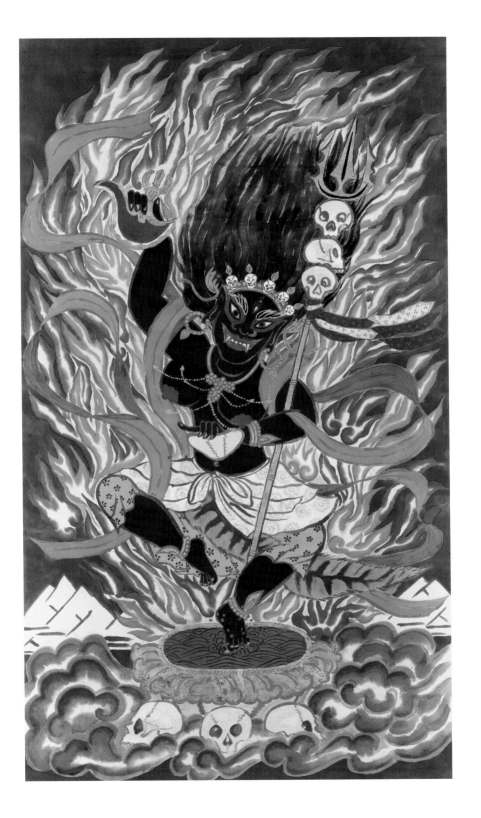

Lady Yamantāka

60 x 117 inches, 1995

For the fiftieth anniversary of the tragic events at Hiroshima and Naga-saki, I painted this representation of the goddess of the hell realm, Lady Yamantāka, praying while sitting on a black bull. (In Tibetan thangkas, black is depicted as dark blue.) She has three faces depicting anger, joy, and serenity. In her left hands she holds a trident and a rope. In her right hands she holds a teaching stick and a sword.

I exhibited her in 1995, taking her all over the world. As a thangka, the image was easy to roll up and travel with, and we used it to express the work of Plutonium Free Future.

Yamantāka is the Tibetan counterpart of the god Pluto; both are guard-ians of the hell realm. Pluto was very strong in my astrological chart in 1995. I drew Lady Yamantāka, my Pluto, in a golden garden with a headband of skulls.

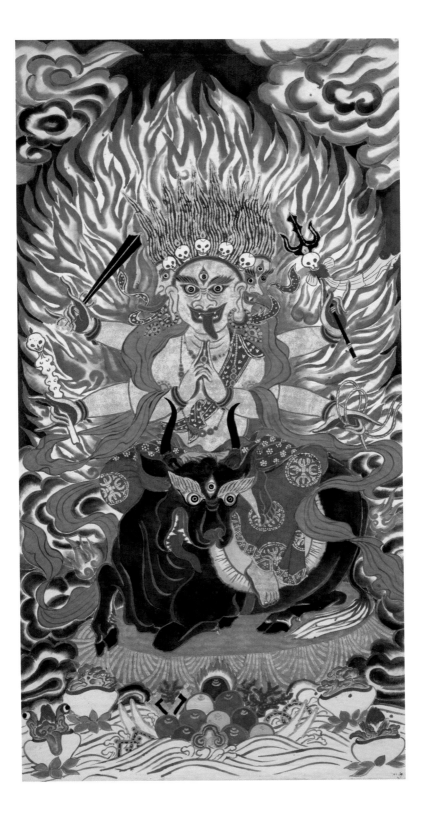

White Mountain Goddess

48 x 105 inches, 1995

When I was helping to publicize the Japanese government's importation of plutonium in the 1990s, including suing them, I was very scared. I felt I needed to receive protection from Mother Earth, so I started to go to Mount Shasta, a sacred mountain in Northern California.

My first trip was in the spring, and wildflowers bloomed in the valley below the mountain. Standing in front of her for the first time, I saw a huge, spreading, snow-covered mountain with a big blue sky.

I felt like I was back in my homeland, back in the place of my heart.

Mount Shasta is called the "mountain of Nu Chumash," as the goddess of the Chumash Indians. The source of the headwaters of the Sacramento River flows out from her stomach. When I drank this water, my body was cleansed, my heart was supported, and I felt very strong. I visited Shasta often, to collect water and carry it with me to Japan.

I painted the Japanese Kukuri goddess. In this painting, I depicted the Japanese Kukuri goddess, also known as White Mountain Goddess, in a redwood forest, carrying a black pottery water vase of the Pueblo style, decorated with a bear paw. I also painted a waterfall, flowers, and frogs, like the ones I saw every day on Mount Shasta.

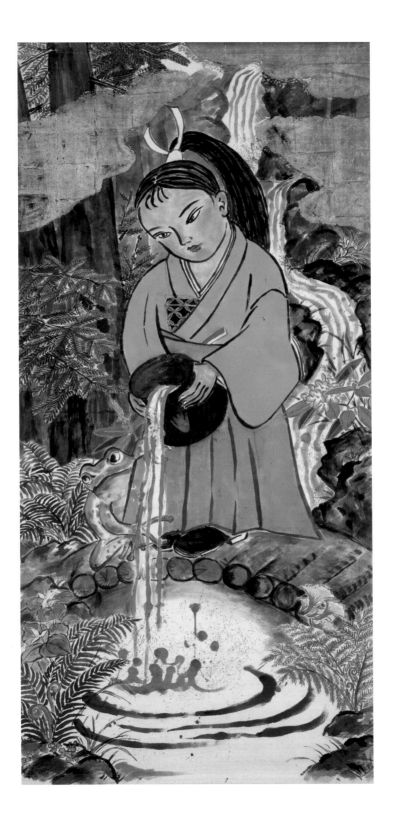

Red Fudo Myo-O

60 x 106 inches, 1994

When Saint Kōbō-Daishi (Kūkai) brought Shingon Buddhism to Japan, he came with wrathful deities guarding the Dharma. One of the wrathful deities was named Fudo Myo-o.

I felt righteous anger toward the nuclear patriarchy, toward the civilization that doesn't take care of the lives of women and children and life itself, and I needed to express that. I wondered, "What if Fudo was depicted as a female? What would she look like?"

Fudo sits on a cremation ground. Her passion is so strong that it burns like a fire behind her. She carries a rope in her left hand, and in her right hand she holds a dharma sword with green dragon protectors wrapped around it.

For the fiftieth anniversary of the bombing of Hiroshima and Nagasaki, I painted her as a female with two boy children attendants, who are known as *Kongara Dōji* and *Seitaka Dōji*. As a mother of two sons, I really felt strong emotions as I created this image.

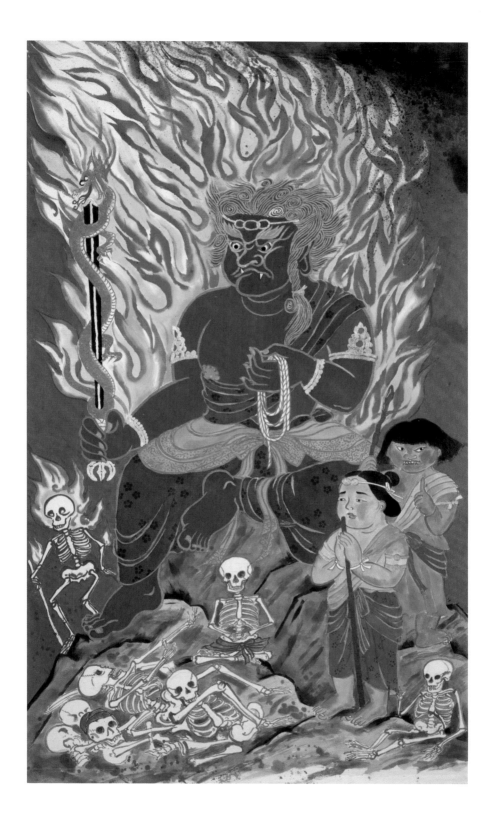

Blue Fudo Myo-O

60 x 106 inches, 1994

After the Fukushima Daiichi nuclear meltdown, our fears became a reality. People in Fukushima are now standing up and showing their righteous anger, demanding that the government and the power industry tell the truth.

But even so, they still have to live with this situation, which is so unfair. Fukushima was farm country. There were orchards, chickens, dairy farms, and beautiful rice fields. It's a famous region for growing cherries, apples, pears, and vegetables. A lot of food came from Fukushima, and it was sold all over Japan. Now their earth is so contaminated they can no longer farm there, and besides, people don't want to buy food from Fukushima anymore.

Tens of thousands of people gathered in protest, but still the government hasn't responded. Their righteous anger is rising more than ever. The government still says that the nuclear reactors are safe. At the same time, as more earthquakes happen than ever before in southern Japan, people are rising up, to protect their children, their lives, and their future.

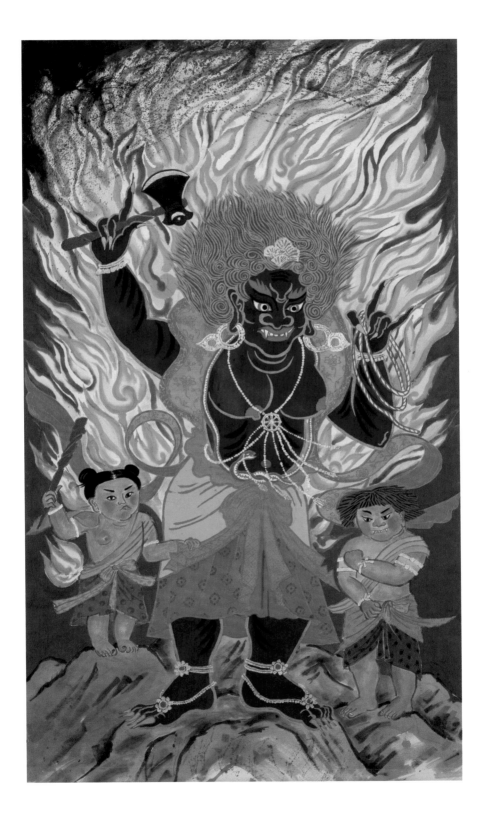

Guadalupe
48 x 91 inches, 1995

Our generation, having created nuclear weapons and nuclear power, has left such a sad legacy to this world. So, I made this painting. Madonna is very sad and tries to protect the children with her star cape.

I exhibited this Guadalupe at the International Court of Justice, or World Court of the United Nations, at The Hague, Netherlands, as our case on the legality of nuclear weapons was heard.

I exhibited her between the Red Fudo Myo-o and the Blue Fudo Myo-o in front of the gates of the court, so that the judges could see her as they came and went. While we carried her, we chanted the *Lotus Sutra* to pray for a good judgment.

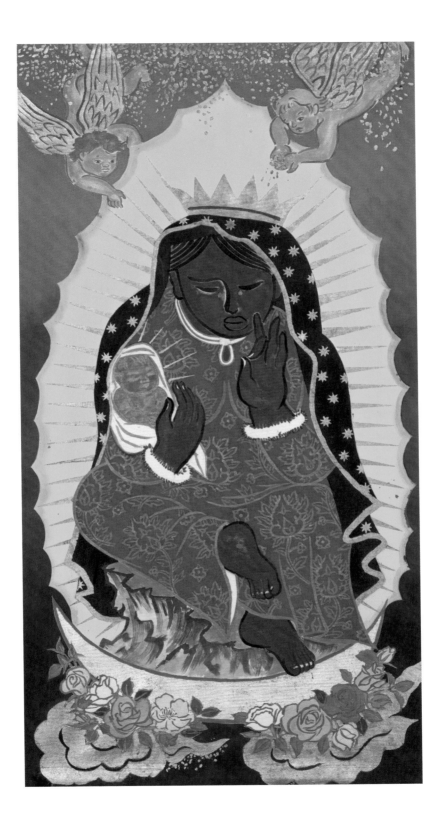

Black Tara

60 x 115 inches, 1999

Before I left for the peace conference at The Hague in 1999, I gathered with four other women in a Hawaiian cave. We walked through a lava tube shaped like a birth canal that opened into a wide flat area, where we sat in a circle in the pitch-darkness. There were formations on the ceiling of the cave shaped like breasts, dripping rainwater. We collected the water from them and drank it.

The Hawaiian *kupuna* (elders) received a chant:

Ho'o mana'o ana no ika wahine
Ho'o mana'o ana no ika wahine
Ho'o mana'o ana no ika wahine

This chant means "Just remember the strength of the women."

I have never seen an image of Black Tara, but this is the way she came to me—like the Tibetan deity Mahakara. Here the dharma protector is a goddess sitting on an elephant skin in front of a burning tree, surrounded by blackbirds.

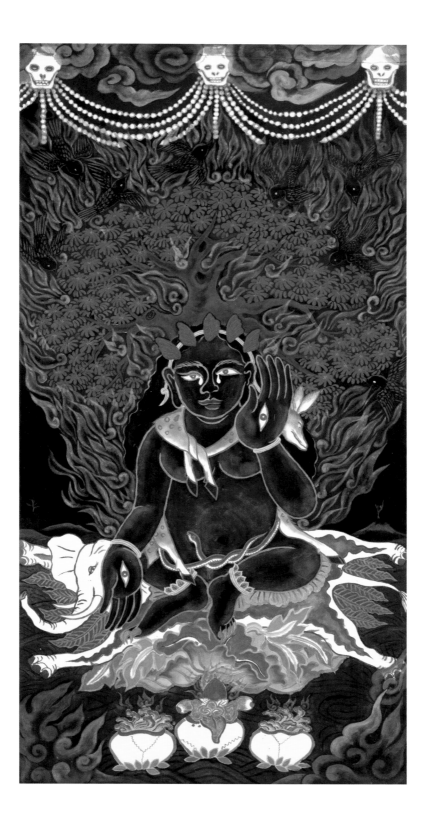

Eight-Armed Sarasvati

60 x 117.5 inches, 2004

In 1999, I received a message from Sarasvati to fight against the nuclear disaster in Japan. I spent five years working as an activist. It was so difficult, and afterward I came back to the studio to paint. I reflected back on that time and painted this eight-armed Sarasvati.

Sarasvati as a warrior goddess was traditionally painted this way, with eight arms. In her eight arms she holds the different means of fighting and protection that I used to fight nuclear energy in Japan. I felt like I had to use all these arms myself.

As a warrior, she carries the following implements:

Left Hands	Right Hands
bow	arrow
sword	three-prong halberd
ax	single-arm vajra
noose	ring

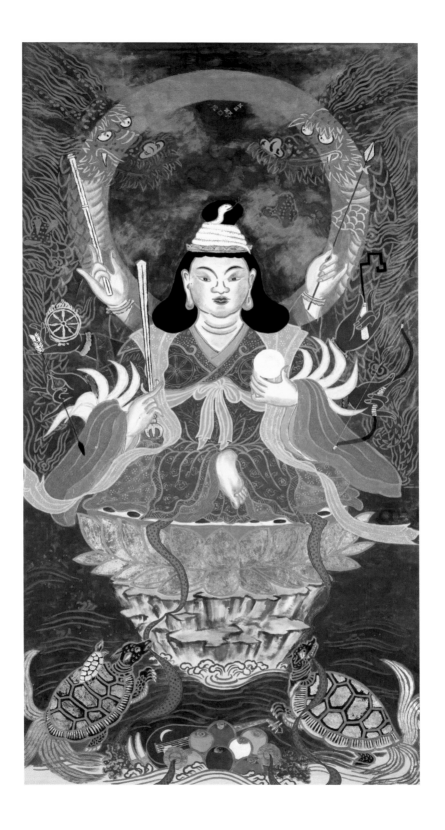

Eleven-Faced Quan Yin of Hakusan

60 x 110 inches, 2010

The Kukuri Goddess of Hakusan probably originated in Korea, when the country was called Kokkuri, and was subsequently brought to Japan. The word *kukuri* means "tied together," like a connection between two places— this world and the spirit world. In Korea, the otherworld is represented as white.

Saint Taichō, a Shugendo monk in the eighth century, explored Mount Hakusan in the Ryōhaku mountain range and established it as a shaman's practicing ground. It has many temples and shrines around various parts of the mountain range. It covers a large area, including four prefectures. The water from the peak of Mount Hakusan divides into many tributaries and is often depicted as a nine-headed naga. The rich water flows below, creating fertile rice fields. Dōgen Zenji (also known as Eihei Dōgen), the founder of the Soto school of Zen Buddhism, opened a training center alongside this nine-headed dragon river.

Taichō, whose own ancestors may have been from Korea, founded his shamanic training center after he had a vision. He saw an eleven-faced Quan Yin, sitting in a lotus on Midorigaike, or Turquoise Lake, which is near the summit of the mountain. Each face represents an aspect of the bodhisattva; with her many faces she is able to see in all directions. Taicho had a statue made of this. It was kept in the shrine at the top of the mountain.

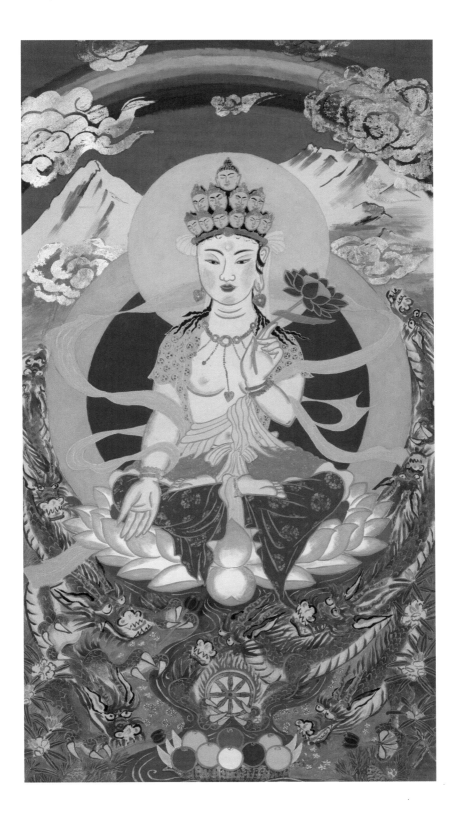

Hearing Sarasvati's Call

IN 1991, the US led a massive bombing attack to begin the Persian Gulf War. I felt distraught. The war was so obviously about oil, and young men were being sent to fight and kill and die for the greed of corporations. My son Jeremiah and his high school friends signed formal conscientious-objector statements and marched in San Francisco to protest the war. I transformed a large willow tree in my yard into a sculpture I called *Tree of Tears*; I hung fifty plastic bags filled with water from the

Tree of Tears art installation at Goddess of the Valley studio near Green Gulch Zen Center, sunlight streaming through plastic baggies of water (1990). Photo by Angela Longo.

branches to represent the tears of Avalokiteshvara Bodhisattva, who gave birth to the goddess Tara. I felt helpless about all the violence and that I could do nothing more than hang bags of water on a tree. The tree's tears glittered in the sun. I chanted the Great Compassion Dharani while beating a Pueblo drum.

Later that year when I turned fifty, I had a party in my garden. It was June, and the grounds burst with lavender, roses, foxglove, and columbine. My garden was a source of great nurturance for me and, along with Zen meditation, it helped soften my heart. With conscious breathing and reengaging the feminine, I was able to stay present with painful memories. Tears dissolved the edges of my past, and my heart absorbed love like a sponge. It was a profound time of healing for me.

My goddess images had connected me with many women who were themselves awakening. We inspired and taught one another to embrace new paths of healing. At my birthday gathering we celebrated how powerful and beautiful our circle of friends had become and recounted the many blessings in our lives. Celebrating this way was a huge contrast to my life as a young woman in Japan. In that moment I knew I needed to return to my homeland to support other Japanese women, who were second-class citizens in their own land, which was now face-to-face with the poisons of nuclear power.

A Plutonium-Free Future

I was dismayed at what I saw when I returned to Japan. Beautiful, old wooden houses had been torn down and replaced by concrete apartment complexes surrounded by commercial developments. Bullying among children had become a national issue, and people of all ages were committing suicide in large numbers because life with its societal pressures was just too demanding. It was a lifestyle that did not respect life. Japan had entered the nuclear age, aligning with the US in the Cold War and adopting a nuclear policy in accord with the terms of the Japan-US Treaty of Mutual Cooperation and Security (ANPO). A country smaller than California, Japan had built more than forty nuclear reactors, and the government was planning

to build more. I couldn't believe the country that had been devastated by Hiroshima and Nagasaki would do this.

A friend, Yumi Kikuchi, gave me a small pamphlet that described Japan's secret plan to use plutonium as a major source of energy. Plutonium, the highly radioactive element first isolated by Dr. Glenn Seaborg and colleagues at the University of California, Berkeley in 1940, is named after Pluto, the god of the Roman underworld. Plutonium provided the material for the first nuclear device detonated at Alamogordo, New Mexico, on July 16, 1945, and for the second nuclear bomb, "Fat Man," dropped on Nagasaki on August 9 that same year. (The first nuclear bomb used in war, dropped on Hiroshima, was composed of uranium.) The half-life of the longest-lived isotope in plutonium takes eighty-one million years to decay to *half* its level of radioactivity. When in the human body, plutonium is transported through blood proteins, and twelve milligrams is lethal. Bone marrow and the liver are especially vulnerable. It takes about twenty years for plutonium to be eliminated from the liver.

The pamphlet Yumi gave me, published by the Citizens' Nuclear Information Center, explained that for many years, Japan had been sending spent nuclear waste from its civilian reactors to France and England to be processed into plutonium. Decades of research had led to fuel reprocessing and prototypes of fast-breeder reactors that were said to run on plutonium and produce more fuel than they use. In Japan, this was called *dream energy* by the Japanese government. In fact, it turned out to be a false dream. Other countries around the world have abandoned this dangerous technology but, although Japan's original fast-breeder, Monju, is no longer operating and will be decommissioned, Japan continues to explore the use of fast-breeder reactors in humankind's oldest dream of unending wealth and power.

In the early 1950s, President Dwight Eisenhower announced the peaceful use of nuclear energy in his "Atoms for Peace" speech delivered before the UN General Assembly. Japan, ground zero of the first atomic bomb, ironically became a promoter of the peaceful use of atomic energy by denying the adverse health risks to second- and third-generation descendants. After the 1986 Chernobyl nuclear disaster in the Soviet Union,

the International Atomic Energy Agency sent a Japanese government epidemiologist there expressly to report that it was safe for residents to return to their villages. Denying the effects of radiation poisoning, that epidemiologist would become responsible for the deaths, some say, of over one million people.

In October 1992, I learned that the Japanese government was planning to receive 1.7 tons of plutonium from France—enough to make 150 nuclear bombs—for its fast-breeder reactor program. These shipments were scheduled to continue for ten years, sending a total of thirty tons of plutonium back to Japan. I was enraged and devastated. How could a fast-breeder reactor be safe in Japan, where so many earthquakes, tsunamis, and other natural disasters occur? Who was looking out for the future of our children?

At the end of my travels, in December 1992, a friend took me to Tenkawa Shrine, a major ancient temple of Sarasvati, for the end-of-the-year mountain goddess ceremony. I was drawn to a huge ginkgo tree there, planted twelve hundred years ago by Saint Kōbō-Daishi (Kūkai). Once two trees, a male and a female, their trunks had eventually intertwined and then grew together as one. I went up to the tree, opened my arms, and hugged the large trunk. I could feel the pulse and energy coming from its roots. I asked the tree, "What can I do to help?"

After returning to California on New Year's Day, I sat in morning meditation in front of my Sarasvati statue, and I heard her say in a loud voice, "Stop the plutonium shipment." I was stunned. I took a breath and said, "I can't do that. I'm only an artist." She answered, "Help will be provided." The voice was so vivid and strong I couldn't resist, and so I determined to do something. My children were grown and on their own, and I had saved money from the sale of my goddess prints in the 1980s—this seemed like the right time to use my gifts to help the world. I determined to stop painting for a time so that I could focus totally on antinuclear activism.

I spoke with Japanese peace activists in the Bay Area and shared my concern over Japan's plutonium plan. We ended up forming a group called Plutonium Free Future. Soon, several of us—peace activists, journalists, writers, and artists, including Kazuaki Tanahashi, Tamio Nakano, Fusako

My artwork on the cover of a *Plutonium Free Future* booklet, second edition (1992).

de Angelis, and Muro Kenji—would go on to found the NGO Inochi, which means "life force." We worked together with Greenpeace International and the Nuclear Energy Institute in Washington, DC, to take action. Every step of the way, I felt that I was being led and supported just as Sarasvati had promised. While much of our work was public and

recorded—conferences, publications, and meetings with officials—there was, of course, a story behind the story.

When we focus wholeheartedly on our intention, we connect with the inner source of life and feel the power of the Divine working through us. My colleagues and I at Inochi shared the intention to stop the plutonium shipment, and we felt the power of this life force growing in us, which allowed us to become more courageous than we could have ever imagined. We experienced miracles: we raised funds, created awareness through media outreach, and derailed the dangerous use of plutonium. But eventually we realized that there was more at stake, and we widened our intention from not only preventing the plutonium plan but to protecting all life.

This experience remains relevant today, when we are all, once again, on the verge of a seemingly insurmountable challenge. If we focus—a skill set available to all—miracles can come from the universe. This innate power, coupled with access to the vast pool of information readily available online, gives people in this moment an ideal opportunity to take back our power—*power to the people.*

Floating Chernobyl

Around this same time, my international art dealer, Norman Tolman, asked me to exhibit my work at the Foreign Correspondents Club in Tokyo and address a luncheon of forty international journalists about Japan's nuclear plans and the pending shipment of plutonium from France. The presentation was very well received by the foreign correspondents, whose stories were not censored by the Japanese government. A few weeks later, *Newsweek Japan* printed a nine-page cover story titled "Japan Loves Nuclear." Every subway in Tokyo displayed a *Newsweek* ad displaying that headline. The word was out. I had revealed a government secret, and I was scared.

I made a silk-screen print called *Earthship* that showed Mother Earth sitting on a treasure ship in the sea surrounded by zodiac animals, whales, turtles, and other ocean life, holding the globe on her lap. I made a hundred copies and sold most of them to collector friends for $300 each. This raised $20,000, which I used to help expand Inochi. In addition, we received a

substantial donation from a private foundation. With the support of Dr. Jinzaburo Takagi of the Citizens' Nuclear Information Center, we created and distributed three thousand pamphlets titled "Japan's Plutonium: A Major Threat to the Planet."

Kazuaki Tanahashi, a peace activist and Japanese Buddhist scholar, gave up his work and joined our group. He attended the Earth Summit—an international environmental conference in Rio de Janeiro—with a suitcase stuffed with pamphlets and handed them out to international delegates. Suddenly people from all over the world, including Latin America, knew that the plutonium shipment would be sailing to Japan by way of the Panama Canal and the Pacific Ocean. I thought we'd need to buy a full-page ad in the *New York Times* to publicize the shipment, and I was prepared to use my life savings to do so, but it turned out not to be necessary. As word got out, scientists, economists, and environmentalists from around the world wrote feature articles, some referring to the shipment as a "floating Chernobyl."

Julian Gresser, an international attorney and former senior consultant to the US State Department and the Prime Minister's Office in Japan, was also a fellow Zen practitioner. A friend brought him to dinner at my house once and said, "Maybe Julian can help." I hadn't met him before, but he'd heard about Japan's nuclear plan and offered to help us. "We can sue the Japanese government first," he said, "by filing a petition of objection to this shipment."

Julian already had a trip to Japan planned for September, six months before the shipment. I contacted eight Japanese attorneys involved in antinuclear lawsuits, and they invited us to meet with them. We went to their well-appointed hotel, and I was surprised to see one of the attorneys wearing formal Japanese dress—*haori* (a kimono-like jacket) and *hakama* (traditional loose trousers). Plutonium Free Future had filed a formal international petition of objection—a preliminary action for suing the Japanese government—and these lawyers agreed to oversee the petition's progress. After the suit was filed, we sent a letter to Prime Minister Kiichi Miyazawa and his minister for the environment, informing them of our actions. In a moment of weakness, I wondered, "Who in the world is going to pay for

all of this? I've done an outrageous thing!" But it felt right, even if I had to spend all of my savings!

The day before our meeting with the attorneys, I had joined my friend Yumi, who organized a National Beach Cleanup Day. We met at the beach where as a child I would watch fisherman pulling in nets filled with *aji*, mackerel. As we worked together to retrieve thousands of scraps of plastic garbage out of the ocean and off the beach, she and I discussed actions to stop Japan's use of plutonium.

After the cleanup, we crossed the long bridge to the small island of Enoshima to visit my favorite Sarasvati temple on the top of the mountain. I remember taking the steps to the back shrine called Oku-no-miya and putting my head on the ground. Then I offered 108 prostrations and prayed for help. It felt like something I was doing was right.

The next day I went to the law office and one of the attorneys told me, "If we win this case, we will break the nuclear chain of Japan that we have been fighting for decades. We can do this free of charge. You don't need to pay us." Then he added, "Why don't you ask people who sign the power of attorney to support the petition of objection to pay thirty dollars each to raise money toward the legal costs?" I was speechless and grateful.

In early November, just days before the *Akatsuki Maru*, the ship carrying the plutonium, was scheduled to depart from France, four hundred international journalists gathered at Port de Cherbourg to witness and write about this dangerous voyage.

Rainbow Serpent

When we formed Plutonium Free Future, most members were mothers with small children. We dressed the kids in hats, masks, and yellow plastic raincoats with duct tape around the bottom of their sleeves, as if to protect them from nuclear fallout. We marched to Parliament in Tokyo, where we delivered 2,200 signatures from people in Japan as well as from organizations and government officials from fifty-two nations. In response to our petition, the Japanese government held the first international pub-

lic hearing on its plutonium program on December 14, 1992. More than sixty petitioners attended, including scientists, lawyers, and leading international antinuclear activists. I attended with Tyrone Cashman, my friend and partner from the American Wind Energy Association.

The "floating Chernobyl" had departed Cherbourg and was on its way to Japan. Many nations—including Brazil, Chile, Argentina, South Africa, Indonesia, Malaysia, and several South Pacific Island nations—banned the ship from entering their territorial waters, which added thirty days to what would have been a month-and-a-half sea voyage. The ship was pulling the dragon's tail of shame for Japan. In January 1993, the *Akatsuki Maru* arrived at Tokaimura. By that time, the Liberal Democrats, who had been in power in Japan for thirty-eight years, had failed to keep their majority, and a coalition of parties, including socialists, formed a new Japanese government. The same day the *Akatsuki Maru* arrived in Japan, we moved into our first formal Inochi office in Berkeley, having previously worked out of our living rooms and kitchens.

The Japanese government reported that they would not be using this plutonium for the Monju fast-breeder reactor, because it was impure. Hearing this, we realized this plutonium wasn't just for energy but also for military use. The Treaty on the Non-Proliferation of Nuclear Weapons was going to be reviewed by the UN in 1995, and we saw this as the moment to make Plutonium Free Future an international movement. Claire Greensfelder, the director of Greenpeace USA's Nuclear Free Future campaign, joined our group, with the mission of providing information about military nuclear proliferation and presenting alternatives to nuclear energy.

Ironically, Monju, the name of the nuclear power plant, is the Japanese pronunciation of Mañjuśrī, the Buddhist bodhisattva of wisdom. He is depicted in art and iconography with a sharp sword of discernment that slices through delusion. Even more unfortunately, the power plant was named by the abbot of the Eiheiji monastery, the head temple of the Soto school of Zen Buddhism practiced worldwide. And to emphasize the bizarre nature of this even further, the premier translator into English of the magnificent works of Dōgen Zenji, the founder of Eiheiji in the

thirteenth century, is Kazuaki Tanahashi, the antinuclear activist who cofounded Inochi. Both the Monju Nuclear Power Plant and Eiheiji are located in Fukui Prefecture.

Claire and I formed Rainbow Serpent, also known as Plutonium Free Future Women's Network, to work with women around the world to change the nuclear patriarchy into a solar-based community of friends and activists. We wore T-shirts with my artwork image titled *Earthship* on them and carried banners with the seven colors of the rainbow as part of our campaign. Several women friends of ours generously donated thousands of dollars each to underwrite our actions and became known as the Rainbow Serpent Sisters.

Me and Claire

Uranium-235 is the only naturally occurring material that can sustain a fission chain reaction, releasing large amounts of energy. In planning our nuclear nonproliferation campaign, Claire and I traveled to New Mexico and Arizona to learn more about the consequences of uranium and coal mining on the indigenous peoples in these states.

In September, 1993, we attended the Southwest Indigenous Uranium Forum as well as the Patron Saint's Feast Day Festival in Paguate, one of the six villages of the Laguna Pueblo in New Mexico just adjacent to the former Jackpile uranium mine—at one point the largest open-pit uranium mine in the world and a source first of jobs and later devastation to the health of the peoples of Laguna and nearby Acoma Pueblos. After the forum, we visited with Hopi messenger Thomas Banyacya Sr. (1909–1999) and his wife, Fermina, on the Hopi Reservation, on what happened to be Fermina's birthday. At that time, I also discovered that Thomas and I shared the same birthday, June 2nd. According to a nine-hundred-year-old tradition, the Great Spirit gave the Hopi the duty of preserving the balance of the world and entrusted them with a series of prophecies. In 1948, Hopi religious leaders, alarmed by reports of the atomic bomb, whose mushroom cloud they saw as the destructive "gourd of ashes" foretold in the prophecies, appointed Thomas and three other elders to reveal and inter-

pret the prophecies to the world. Thomas shared some of this with us, and though I cannot remember precisely what he said, it is reflected by these words of his from the World Uranium Hearing in 1992. I encourage you to go to the website from which this excerpt is taken to read the entirety of his powerful message.

> Man used to walk in the front going through a woods or some-place. [...] Now, today, [...] women will be up at the front.... Menfolk messed this up, they don't want to clean up. It's time for the women to really get after them and help them clean this mess up before it's too late. [...]
>
> Women have a very important part as human beings, and the same way with plant life, trees, animals, birds. Male and female have to work together to keep these green valleys. [...]
>
> But when our white brother makes a gourd full of ashes, it's [like] Hiroshima and Nagasaki. [...] The Hopi [elders] were talking about this, and I was amazed they described that with-out even reading books [or speaking] English, but there in the Hopi language they described exactly what happened at Hiro-shima and Nagasaki, and they said that poison and ash will be floating there for many years. [...]
>
> Uranium mining is a dangerous thing—we know that now. [...] So many things known to the Hopi tell the world not to do that any more. Stop uranium mining, testing. Stop everything. So I hope we will correct this and whoever comes out will meet the Great Spirit on the other end again.*

Claire and I then went to the Kayenta mine, a surface coal mine operated by the Peabody Coal Company on the Navajo Nation. While we were in the Southwest, we met with many local indigenous activists and writers,

*Excerpted from *Poison Fire, Sacred Earth: Testimonies, Lectures, Conclusions—The World Uranium Hearing, Salzburg, 1992, 32–36, www.ratical.org/radiation/WorldUraniumHear-ing/ThomasBanyacya.html.

including Esther Yazzie (Navajo), Manny Pino (Acoma), Al Waconda (Laguna), Marley Shebala (Navajo), and others, and we visited with Jim Enote (Zuni) of the Zuni Conservation Project at Zuni Pueblo to learn about their landmark sustainable development initiative.

In November 1993, Claire, Esther Yazzie, and I traveled to Aomori Prefecture in the northern part of Honshu, Japan, to meet with leaders of the resistance to the Rokkasho plutonium reprocessing facility. We stayed in the Cow Barn Activist Center, joined an anti-Rokkasho march, and spoke at a political rally. Then we traveled south to the Tsuruga Peninsula to meet with Tetsuen Nakajima, a Buddhist priest who is leading the grassroots resistance to a cluster of fourteen nuclear reactors there, including Monju, the fast-breeder reactor.

When we returned to California, women from nuclear sites around the world joined us at my house for a Rainbow Serpent retreat. Navajo, Pueblo, Pacific Islanders from Bikini and Tahiti, Japanese, and other women of color, including Savannah River and Hanford activists, shared experiences, agony, and wisdom, exchanging information and resources over indigenous food we prepared together. We slept under the same roof and spent days working on strategies to prevent a nuclear buildup. We had sleep-ins, demonstrations, and silent vigils, and we held a town hall in Berkeley, California, where the legendary environmentalist David Brower, the visionary renewable energy expert Amory Lovins, and many of the women who attended the retreat offered public testimony.

The Inochi group continued to work day and night to get the word out to communities and government officials about the life-threatening dangers of plutonium, and to this day, we campaign for the total abolition of nuclear power and weapons and promote renewable energy for a safe and sustainable world.

Alternative Energy

Tyrone Cashman had been trained at the New Alchemy Institute, a New England research center that did pioneering investigation into organic agriculture and alternative energy. I met Ty when he was building a windmill

Me at the Inochi Board Meeting in Berkeley, California, with Kazuaki Tanahashi, Claire Greensfelder, and Fusako De Angelis (2018).

at Green Gulch Farm. He was on top of the windmill in the vegetable field and dropped some tools. I grabbed them and climbed up to where he was perched. I never imagined this would be the beginning of a long-term friendship. We practiced with the same Zen teacher, Dainin Katagiri Roshi, and Tyrone became my dharma brother.

Ty had attended Jesuit seminary with Jerry Brown, who would go on to become the governor of California. When Governor Brown created the Office of Appropriate Technology in the 1970s to study and promote sustainable energy, he invited Tyrone to help launch California's wind energy program, which led to him becoming the president of the American Wind Energy Association, a DC-based trade association that represented the wind industry. Ty also helped write the law for the State of California that granted tax credits for solar and wind energy conversion. The funds invested in wind energy helped underwrite the development and deployment of seventeen thousand large wind turbines in California, which played a major part in jump-starting the US wind industry.

Years later, Ty came back into my life. He ended up living just up the hill from me by Green Gulch. He called his home and library with many thousands of books Cloud Mountain, while I called my property Goddess of the Valley. I had been feeling forlorn about Japan's embrace of the fast-breeder reactors that every other country had abandoned. The technology was dangerous, especially for a country with so many earthquakes and other natural disasters. I needed a clear vision for alternative energy. Tyrone and I would hike together in Muir Woods and on Mount Tamalpais to discuss a vision for a solar-hydrogen energy future. During our long walks we decided to form a small think tank about clean energy, which we called the Solar Economy Institute.

In 1995, Ty was invited to give a keynote address at the United Nations University in Tokyo. I had an exhibit of my goddess prints and paintings in Tokyo at the same time to fundraise for Inochi. A few days before his speech, we obtained a tip that plutonium fuel rods were being shipped through Tokyo to the Monju Nuclear Power Plant. Greenpeace Japan invited us to join a demonstration, and at 6:00 p.m. the evening of the shipment, we stood on the edge of the highway beyond Shibuya Station and saw the truck transporting the fuel rods speed by us through busy, rush-hour traffic. We were trying to educate people about the extraordinary danger of shipping fuel rods through a city.

That year, on Buddha's Enlightenment Day, December 8, there was a major nuclear accident at Monju. Since Tyrone was also a practitioner of Soto Zen Buddhism, he understood the irony of Monju being named after the bodhisattva of wisdom. A sodium rod leaked coolant, which led to a massive explosion, creating shock waves on the ground as well as in the scientific community and with the general public. It was the first case of Japanese fallibility in nuclear technology, and it was front-page news in the *Japan Times*. (The back page of the same newspaper featured a half-page article about my art show, *Painting for Mother Earth and Her Children*.)

Three days after the Monju accident, Ty delivered his keynote address titled "Japan's Twenty-First-Century Energy Vision." He offered a renewable energy vision for Japan that would displace the need for nuclear energy, make Japan energy self-sufficient, and lead the world into the next century.

While scientists and researchers felt this was the answer to Japan's energy future, the Japanese government and energy monopoly were not in favor of Ty's vision. However, his address encouraged many people and became the seminal guide for a new energy plan, inspiring a fresh way of thinking about a renewable energy future. Reading his paper twenty-five years later, I'm touched that it still remains such a valuable and workable plan. It's too bad the Japanese government didn't take it seriously; if the plan had been adopted, Japan wouldn't have been relying on nuclear power in 2011 and the Fukushima Daiichi Nuclear Power Plant accident would not have happened.

After that Japan trip, Tyrone and I offered a seminar at my home in California for Japanese attorneys to prepare legislation that would allow private companies and individuals to sell electricity, which would break up the monopoly and open the door to decentralizing electricity in Japan.

Appealing to the World

In the 1990s, the Women's Environmental Development Organization (WEDO), led by former US Congresswoman Bella Abzug, coached me on how to present myself at international conferences. Abandoning Rainbow Serpent T-shirts when we went inside, I now wore Armani blazers and high heels and carried an Italian briefcase. Claire and I attended the Treaty on the Non-Proliferation of Nuclear Weapons conference in 1995 at the UN headquarters in New York. Standing in the General Assembly building, I felt far away from the reality of the natural world. Nevertheless, at plenary sessions and workshops we spoke at length about the civilian use of plutonium in Japan.

Then, Daniel Ellsberg, who had leaked the Pentagon Papers, among his many other activist actions, invited me to attend the Japanese nuclear industry's conference in Hiroshima. The nuclear industry was saying that the antidote to global warming was to move away from fossil fuels and toward nuclear energy. The president of Mitsubishi Nuclear Fuel called plutonium "pure gold."

To get these Japanese leaders' attention, I had to speak to them in

English. When I spoke in Japanese, they dismissed me as an irrelevant woman. I asked how much research they'd done on the dangers of nuclear reactors in an earthquake or a tsunami and how they were preparing for the storage of nuclear waste. They told me they had it all under control.

The year 1995 marked the fiftieth anniversary of the nuclear bombing of Hiroshima and Nagasaki. It was also the year the UN reviewed the Treaty on the Non-Proliferation of Nuclear Weapons and held the fourth World Conference on Women, hosted in Beijing, China. It was crystal clear to us that decentralized energy—generated, stored, and distributed by a variety of small, grid-connected devices, rather than a single centralized source— was the answer. The Plutonium Free Future Women's Network wrote and published *The Women's Handbook on Safe Energy*, which I illustrated. Claire Greensfelder took thousands of copies in both English and Chinese to the World Conference on Women in Beijing and distributed them to many women who had not heard very much about the real possibilities of alternative energy. The booklet was so well received that after the conference, volunteers from around the world translated it into Spanish, Russian, French, Ukrainian, Turkish, Uzbek, and seven other languages, resulting in over fifteen thousand copies in print in fourteen languages.

That same year, I joined the Atomic Mirror Pilgrimage, which brought activists together to pray for the worldwide abolition of nuclear weapons. The pilgrimage was intended to prepare us for the project to make nuclear weapons illegal under international law. We began our pilgrimage with activists from many backgrounds, nationalities, and beliefs on July 14 at El Santuario de Chimayó in New Mexico, the sacred place of Our Lady of Guadalupe.

Miki Tsukishita, a calligrapher and Hiroshima survivor, came from Japan to return the fire of the atomic bomb to its source in New Mexico as part of the Atomic Mirror Pilgrimage. He carried it inside an ancient vessel containing fire used as a body warmer—*hakkin kairo*—from the Peace Park in Hiroshima and handed it to Los Alamos National Laboratory. The next day we walked to the White Sands Missile Range and had an all-night vigil, sitting in a circular white tent. Rain poured all night long, as we watched in the center of our circle the Hiroshima flame that had burned

for fifty years. The next morning, after having left half of the flame at Los Alamos, we held a ceremony at ground zero in Alamogordo and left gifts to heal the earth, symbols of the elements, the other half of the flame, water in a vessel, sand in a container, and wind symbolized by the wing of a bird. We then went on to visit sites that represented the nuclear supply chain, including uranium mining areas in the Navajo and Pueblo reservations of Arizona and New Mexico, nuclear test sites on Western Shoshone land in Nevada, and Livermore laboratories in California. Our pilgrimage ended overseas at Hiroshima and Nagasaki.

Two years later, in December 1997, Claire and I attended the third Conference of the Parties of the United Nations Framework Convention on Climate Change (UNFCCC-COP 3) in Kyoto, Japan, where we worked with Dr. Jinzaburo Takagi and others to challenge the idea that nuclear power was the answer to climate change and to promote safe renewable energy sources. We revised and reissued our booklet as the *Safe Energy Handbook*, distributing another three thousand copies in English and Japanese. Once there, we organized the first Women's Caucus inside a UNFCCC-COP and issued a statement—"The Women's Witness at COP 3"—that was endorsed overnight by hundreds of women (and men) from around the world. We called a women's press conference, and with my Amaterasu thangka as our backdrop, the Women's Caucus demanded stronger agreements. In Kyoto, we worked 24-7, joining forces with the No Nukes Asia Forum, Greenpeace, and other civil society organizations to speak on panels, organize actions, lobby governments, and conduct interviews with CNN International, *Asahi Shimbun*, and others. It was a remarkable two weeks of sleepless nights and nonstop action for our small but mighty Inochi team of two.

Suddenly the Stone Felt Weightless

To prepare for visiting Nagasaki and Hiroshima, about twenty-eight people from all over the world came together to do a ceremony near Nara, Japan. We stayed in a big house in Nara. A huge cedar tree stood outside, and there was a small shrine nearby with a perfectly round pink rock inside.

A female shaman among us said that the pink stone wanted to go back to the Tamaki Shrine nearby. Heeding her, we wrapped the stone in my raincoat and brought it to the shrine, where we cleansed it under a waterfall and had a Shinto priest bless it. He gave us white robes in which to dress the rock, and he asked us to put it in a cardboard box. We hung the box from wooden poles, which four of us carried on our shoulders up the mountain to the shrine of the Thunder God, Oomunaji.

As we began the ascent, the stone was so heavy we could barely lift it, but as we continued to climb up the steep trail, the stone suddenly felt weightless. We each thought the other was taking all the weight, but that wasn't the case. As if by magic, the stone became lighter on its own. When we arrived at the shrine, we took the stone out of the box and placed it on a large boulder in the shrine of the Thunder God. As soon as we placed it there, thick mists moved in and covered the whole area. The Shinto priest laughed and said that the pink rock was marrying the larger boulder and they must feel shy about it. The rising fog was the veil for their sacred union.

Later, we discovered that the pink stone was the same size as the trigger in the atomic bomb "Little Boy" that was dropped on Hiroshima. Although we didn't know it at the time, we were enacting an event that had taken place fifty years earlier when a prototype nuclear bomb was carried from Los Alamos to White Sands Missile Range to be detonated. The smooth, pink, round stone was the opposite of the black atomic bomb. It was a feminine symbol that represented healing the devastation that the atomic bomb had perpetrated on the people of Hiroshima, Nagasaki, and the world. Carrying the pink rock to the masculine Thunder God shrine was the most healing part of our pilgrimage.

International Court of Justice

In November 1997, I traveled to The Hague to join the World Court Project, organized by the Lawyers Committee on Nuclear Policy and three other international organizations. I spent two weeks there working

with people from all over the world, lobbying to make the use of nuclear weapons—and even the threat to use nuclear weapons—illegal. That autumn in the Netherlands, cold wind was blowing from the North Sea, and all the old buildings looked dark and gray. Hundreds of people joined us, including members of the Japan Council against Atomic and Hydrogen Bombs, the mayors of Hiroshima and Nagasaki, and key individuals such as Dr. Jinzaburo Takagi, a longtime activist who had worked in the nuclear industry. I have a beautiful memory of Takagi, a humane, soft-spoken man with a strong will, organizing workshops and seminars there.

Blue Fudo Myo'o, Guadalupe, and *Red Fudo Myo'o* thangkas in front of the International Court of Justice at the Hague, with the then mayors of Hiroshima and Nagasaki (1992).

For fourteen days we gave testimony to the court's international judges, presenting reasons and evidence for opposing nuclear weapons. I had painted a special thangka, the Black Guadalupe Madonna, and hoisted her between images of two wrathful goddess figures, Blue Fudo Myo-O and Red Fudo Myo-O, for the occasion. Carrying these banners, we gathered in

front of the International Court building with Nichiren Buddhist monks chanting "*Namu-Myōhō-Renge-Kyō*," meaning the great *Lotus Sutra*, and beating taiko drums. The International Court ruled that the threat or use of nuclear weapons is generally illegal and that states have an obligation to conclude negotiations on their elimination. Unfortunately, although it made headlines in Japan, Australia, New Zealand, and other countries, it never became news in the US, and most Americans don't know and do not care about the World Court's decision.

In 1999, The Hague Appeal for Peace convened. The idea was to start the steps and sow the seeds for the abolition of war, to declare peace a human right and to design a culture of peace, not for a year or a decade but forever. A thousand miles away in Kosovo, war was raging, and NATO was using munitions laced with depleted uranium (DU). That was on the shores of the Danube, which runs through the Kosovo basin and for thousands of years was a fertile land of peaceful agricultural people. Prehistoric goddess figurines had been found at the very sites of these battles. I felt as though the earth were being raped.

DU is a by-product of uranium enrichment used in nuclear reactors and weapons. Because the US Department of Energy didn't know how to dispose of it, store it, or dump it, they sold it at one dollar a ton to replace the lead in bullets, missiles, and tanks. The war in Kosovo was not only killing people, but it was also damaging the earth for future generations. I've heard that today, x-ray protective covers and even frying pans are manufactured with depleted uranium.

I had worked day and night for nearly a decade and still hadn't brought any significant change to the nuclear industry. When I told people about DU and plutonium, no one seemed to care. The military–industrial complex was too big a dragon to slay, and I felt exhausted. When I started this work, I was told it was naïve to think I could stop the plutonium industry. I was determined to bring about change, but now I was seeing how small I actually was in the face of the nuclear crisis. I could foresee a huge nuclear disaster in Japan—an earthquake, tsunami, and nuclear meltdown—and knew my family would evacuate to Hawai'i. So I decided to end my work as an antinuclear activist and begin working to create a healthier society in

other ways. Still feeling strongly that we have to adopt renewable resources and move toward a solar economy, I decided to establish a solar-oriented, organic-farming community in Hawai'i. In this way I could begin to repair society and heal the earth.

White-Robed Quan Yin

60 x 118 inches, 2002

The first participant in my goddess trainings at Gingerhill Farm—the community farm in Hawai'i where I moved in 2000—was Mari Hashimoto, who translated John Blofeld's Quan Yin visualization technique into Japanese. Blofeld was given this visualization by a Chinese nun who didn't want it to be lost when the communists were taking over.

I was inspired by a vision of Quan Yin in the night sky, with her nimbus becoming the full moon. Standing on a white lotus, she is coming from the ocean to cleanse you of your misfortune. Her big hands are in the *semuin* mudra, which means "Do not worry." Together Mari and I chanted a Quan Yin meditation, the *Heart Sutra*, and recorded a CD to help people when they were sick.

Mari went back to Japan, married an American man, and together they practiced Buddhism. She had a baby boy, and soon after got cancer. When he was five years old, she died. When she died, Mari understood death very well. She was ready to pass on because she had experienced so many years of suffering.

They had a beautiful funeral for her with music and chanting. Her death was such an unbelievable loss to me. I chanted the Quan Yin invocation for her passing, and for the protection of her surviving family members.

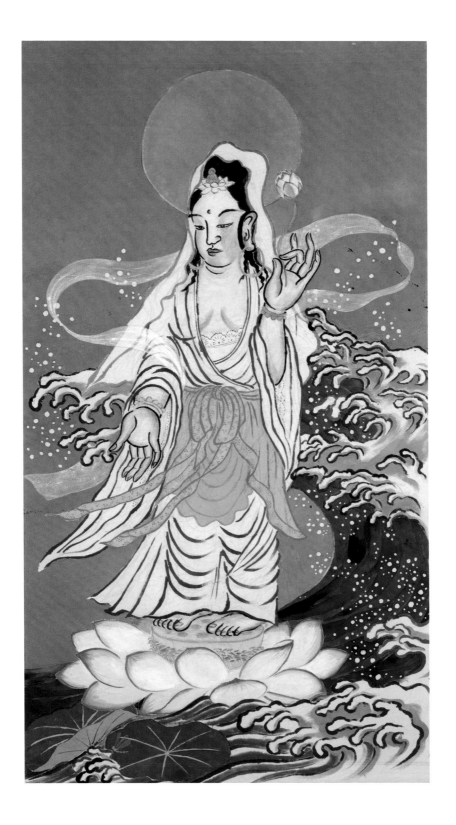

Four-Armed Sarasvati with Pearls

48 x 136 inches, 2009

This Sarasvati is painted in a style similar to the Hindu tradition. She holds a vina, a pearl mala, and a sutra while riding a white swan on the Sarasvati River.

Lots of mornings I do a Sarasvati chant with my pearl mala that I received from Joan Halifax. I do this usually three times, seven times, twenty times, or 108 times.

In Japan, there's a sutra called the *Three-Day Completion*, or *Wish-Granting Sarasvati Sutra*. The sutra requires ten thousand chantings of a mantra:

> om Sarasvati swaha
> om Sarasvati swaha
> om Sarasvati swaha

If Sarasvati considers it a proper wish, she will grant it for me in three days.

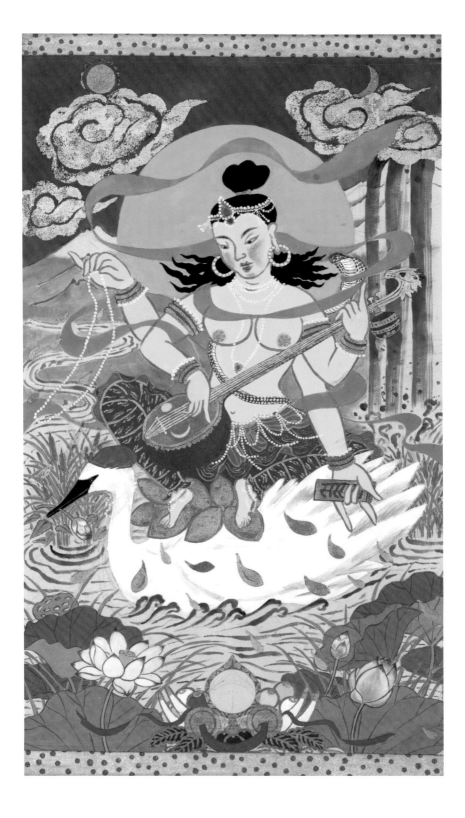

Poliahu

60 x 105 inches, 2008

Poliahu is the goddess of Mauna Kea, the "white mountain," and she represents water. She and Pele, the goddess of Mauna Loa, who represents fire, were rivals, but always water is stronger than fire.

Poliahu sits on a pedestal of Hawai'i's food resource, taro, in the style of a Tibetan thangka. She is holding a white hibiscus flower, and her sister, Lilinoe, the goddess of the mist, appears in the mountain above. She sits by Lake Waiau, surrounded by Hawaiian mountain plants—silversword—and two nene geese. Male and female kamapua'a, pig gods, offer a light and a sweet potato to Poliahu. At the bottom is the offering of the song and dance of Hawaiian music, with the fruits of the land.

Keala Ching, my beloved Hawaiian *kumu* (teacher), served as the model for the figure in the thangka. He taught me hula dance and chant, and he also taught me the essence of Hawaiian culture.

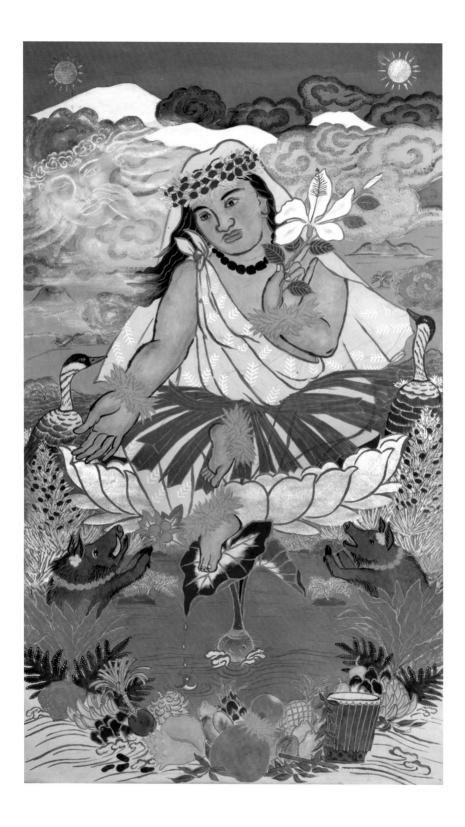

Pele

60 x 105 inches, 2009

Pele is the Hawaiian goddess of active creation and destruction. She appears here as a four-armed, angry goddess, like a Dakini.

After I painted Poliahu, I felt I definitely needed to paint Pele, a rival goddess, but I couldn't see the image clearly in my mind. Around that time, I was holding a Hawaiian body cleansing workshop as taught by Auntie Margaret Machado, the *kupuna* (elder) of Hawaiian lomilomi massage and healing work.

The cleansing involves drinking seawater, which makes your body cold, so we usually made a fire in the fireplace. We would lie down, and since I was hosting, I was giving a massage to a friend. All of a sudden, my fluffy white skirt caught on fire. I tried to roll over it to extinguish the flames. And then I realized Pele had come to me. Then I could paint this image. I wanted to paint her in a more Buddhist way—a combination of Dakini and Pele. Many times, Pele is depicted as an older woman walking with a cane, so I did the same thing.

Fire and water, the two elements of cleansing, gave me the vision of Pele as a red Dakini.

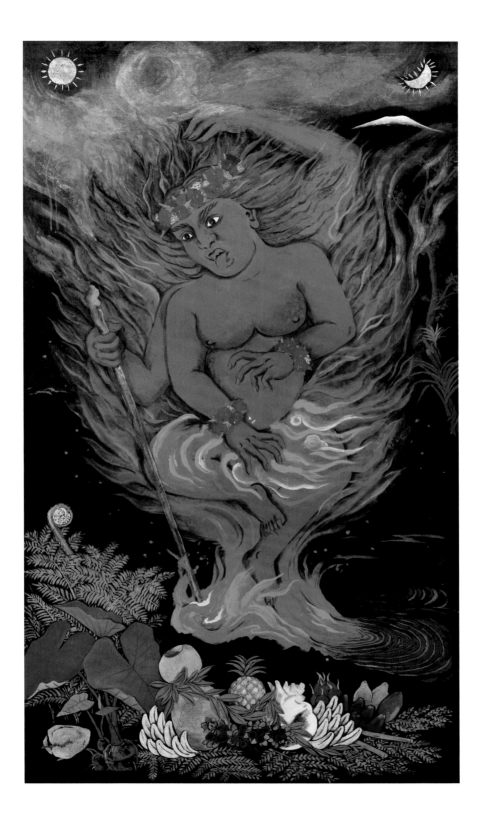

Queen Mother of the West, Seiobo

48 x 107 inches, 1991

Queen Mother of the West, called Seiobo or Xi Wang Mu, was an ancient Chinese Taoist sage who lived on Mount Kunlun. It was said that she grew the immortal peach, which bears fruit only once every three thousand years. Various emperors tried to steal the sacred fruit. Xi Wang Mu becomes a tiger to protect the juiciness of life.

As a young painter, I loved Tomioka Tessai, who was a practitioner of *shingaku*, which means "learning of the heart" and is an integration of Zen Buddhism, Shinto, and Taoism. He himself was the priest of Isonokami Shrine in Nara, very close to where I and others started Toyouke No Mori Farm in 2014.

I wanted to learn his way of painting in the very free style of sumi-e. I did the paintings of Queen Mother of the West, White Mountain Goddess, and Hariti as a way to begin to learn to paint like Tessai.

It was after I painted Queen Mother of the West that I felt as though I could really paint. I realized that I could even paint the beautiful Xi Wang Mu. Knowing this, I felt okay about leaving my painterhood for a while, in order to use my creativity to protect life, in this way embodying the meaning of the painting.

Palden Lhamo

48 x 60 inches, 1988

The Zen practitioner and writer Barbara O'Brien tells the story of Palden Lhamo. She was married to the murderous King of Lanka, known as an enemy of the Dharma. He was also raising their son to follow this same destructive path. Palden Lhamo knew she had to change things before he and their son destroyed Buddhism entirely.

So, she decided to kill her son. After she killed him, she skinned him, drank his blood, and ate his flesh, riding away on a horse with a saddle made of his skin. This symbolizes Palden Lhamo taking her son back into her own body and taking ownership of what she had created. The saddle represents her karma that she must continue to ride.

When the king found out, he flew into a rage and shot an arrow, which hit her horse on its flank. Palden transformed the wound into an all-seeing eye, to help her in her quest of destroying the lineage of Lanka.

I was moved by the story of Palden Lhamo. Somehow it became very important to me to be able to paint this myth. It tells the true meaning of self-sacrifice.

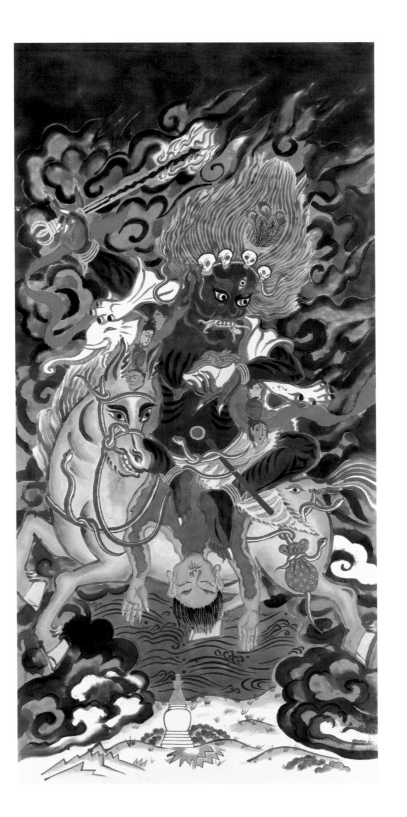

Vajravārāhī

48 x 100 inches, 2013

Vajra is like a diamond, an indestructible truth, represented by a *dorji*, or thunderbolt. Vajravārāhī is a sow—an indestructible sow, representative of the indestructible feminine truth, the guardian of life.

In this thangka she has a pig's crown on her head. She is a sixteen-year-old virgin with a shining red naked body, and she is extremely fearless. She represents the power of lovemaking and the power of destruction. In her right hand she holds a sharp cleaver. With it, she will cut off all illusion and lies without any hesitation. In her left hand she holds a skull cup full of blood.

She's adorned with a necklace made of human heads, which represents material desire. She is dancing on a man who represents business greed, including that of Japan's energy industry, which has brought us tremendous danger at this moment.

I did this painting right after the Fukushima Daiichi nuclear disaster. I consider it my climax painting, because all my antinuclear work was for life, the feminine principle that has been so threatened. Vajravārāhī supports the continuation of life as a feminine principle. She destroys destruction. She's angry at the things that don't protect life.

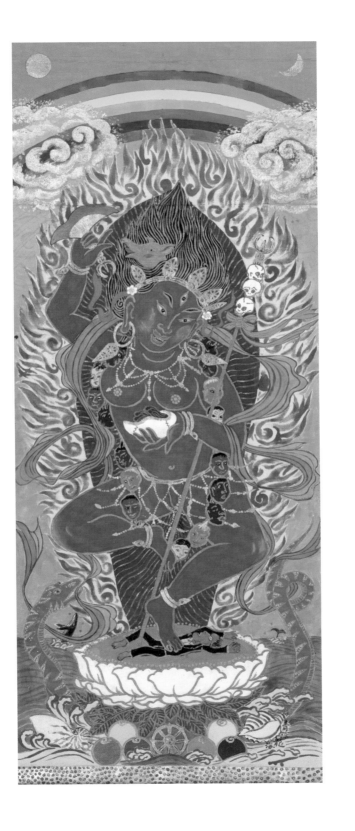

Amaterasu

60 x 102 inches, 1987

In Japan, Amaterasu is the sun goddess. She illuminates the heavens and gives life to all beings.

In legend, her brother Susano'o caused so much mischief on this earth that she hid in a cave, and the world turned dark. The goddess Amenouzume stripped naked and began dancing. The gods started to laugh loudly. Curious, Amaterasu peeked out from the cave and the gods yanked her out.

Japan's imperial household is now the protector of the sun goddess and makes sure she is always there to support us. That's the job of the imperial household—to make certain that bad things don't happen to Japan, things that would make her want to go away again. But because of this association between the imperial household and Amaterasu, unfortunately, the symbol of the sun on our flag became emblematic of our imperial militarization during World War II.

In our Shinto tradition she is the principal goddess. When I started to paint thangkas, this was the most important goddess in my mind, and so she was the first goddess thangka that I painted.

Here she holds the *Yata-no-kagami*, the sacred mirror that is part of the imperial regalia of Japan. The eight sides of the mirror also reflect the eight directions of Taoism.

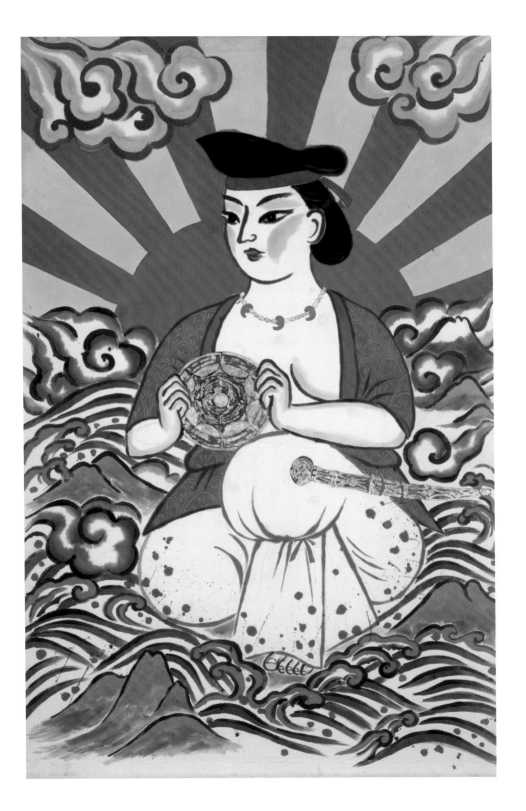

Toyouke-no-Ōmikami

60 x 120 inches, 2015

Toyouke means "receiving fecundity." She is the goddess of food. Shinto believes all the abundance on earth was given to us by the light of the sun and the moon. Goddess Toyouke serves food to the sun goddess Amaterasu. She has been offering abundance from the earth and sea for over 1,500 years. At Ise Shrine, she offers Amaterasu food twice a day, in the morning and in the evening.

When I painted Goddess Toyouke, I was inspired by the shape and strength of the ancient Jōmon goddess, whom I knew from an earthen figurine, the Venus of Jōmon. I see Toyouke as a continuation of the Jōmon goddess, who is similar to the Sumerian goddess Ishtar, holding her breasts. I painted her standing in a golden field of rice with everyday scenes.

My friend Mana Tanakadate started a farm in Nara called Toyouke No Mori, which means the "little forest of the goddess," where people can practice living in harmony with nature. When I painted Toyouke-no-Ōmikami, it came out as if I had painted Mana herself.

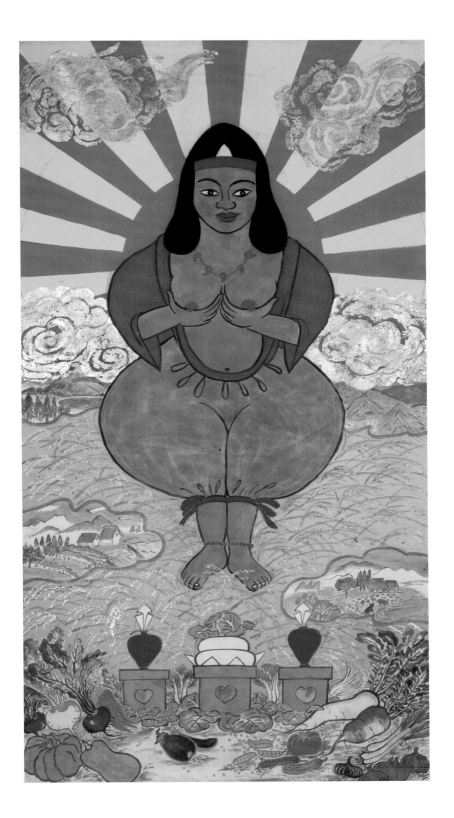

Pan-Pacific Culture

To create a sustainable, sane future, we need to imagine new possibilities and, *at the same time*, draw from the wellsprings of the past. In indigenous societies, particularly in Pan-Pacific cultures, men supported women and children so that a collective healthy lifestyle could generate well-being for all. Decisions were grounded in compassion for seven generations before and seven generations to come. The women selected the village chiefs to be sure the men kept their promise to future generations. In Hawai'i, taking care of our precious lives guided all prayers, chants, and hula. *E Ola* (aloha), the main chant celebrating life, is, I feel, the most important word in the Hawaiian language.

Life brings us here and takes us home. Life has existed before and will go on after us. This principle of ongoing life is also reflected in the Buddhist *Heart Sutra* when it repeats "no eyes, no ears, no nose, no tongue, no body, no mind." We are not merely our bodies but the divine energy of life coexisting in a spiral of perpetual motion. Taking the bodhisattva vow, Buddhists commit to "saving all sentient beings."

Most countries and corporations today are governed by men who ignore the needs of women and children, and thus our collective well-being. There is significant oppression and suffering throughout the world, especially among women and children. Until about fifty years ago, we had sustainable agriculture and caring for one another. But as farmers abandoned traditional methods, we as a people lost our way; we disconnected from nature and ignored the cultural rituals that celebrate gratefulness for food, such as the songs, drums, and chants of rice harvest festivals.

Among the worst acts humans have ever made were the splitting of the atom and the splitting of genes to create genetically modified organisms (GMOs) and seeds. Both violate the integrity of natural regeneration, an

insult to life itself. Do scientists think humans can make better decisions than God, nature, goddesses, or divine forces? These disruptions of nature go right into the sexual organs, affecting the very seeds of life—genital cancers, sperm disorders, and fertility problems show us how we have damaged the natural life cycle and future generations. Humankind's decision to sacrifice food and children is like Midas destroying everything he touches, including his daughter, whom he turned into gold.

At this time of much-needed change, women in Japan and throughout Asia need to step up to positions of leadership so we can make intelligent, holistic, life-affirming decisions for the future. To support more women coming to power, I worked with the Asian Pacific American Women's Leadership Institute (APAWLI) to empower women through leadership training. APAWLI brought Asian Pacific women to the US for seminars, and I led the spirituality portion of the training, focusing on the biological roots of spiritual traditions and our oneness with nature. These workshops were full of caring, capable women. If informed, good-intentioned women step into our power and assume more leadership positions, governments and businesses will make more intelligent, well-considered decisions.

In the year 2000, I bought a five-acre ranch in Kealakekua, Hawai'i, called Gingerhill Farm. *Ke Ala Ke Akua* means "pathway of the Gods." I moved onto the land with the intention of growing turmeric and ginger while building a sustainable community. In addition to organic farming and growing medicinal herbs, I practiced yoga and Zen meditation daily. The ethics of kindness, love, and compassion toward our gardens, our food, and one another permeate every aspect of our lives at Gingerhill Farm even to this day.

Experiencing war as a child, I am aware that during challenging times, growing food is critically important. Young people from all over the world have come to Gingerhill Farm to work, grow fruits and vegetables, cook together, and take care of their bodies and minds. Gingerhill has apprentice programs, retreats, and a B&B where visitors can stay. To start our days, we chant and ring morning bells; at the end of each day, we gather together for a sunset chant. And at the beginning of each meal, we chant:

This food is a gift from the entire universe,
The land, the sky, the ocean, and the work of many people.
May I be the presence that deserves to receive this,
May I learn the right way of eating,
May I receive energy and be protected from illness,
May I walk the path of wisdom and love.
When I eat, may I not forget the people
who are now suffering from hunger in the world.

This chant reminds us that the earth and thus our lives revolve around the sun. We live to honor the rain, the land, the food we grow, and the sanctity of all life.

An amazing daikon from our garden at Gingerhill Farm, Hawai'i (2012). Photo by Yuko Ishikawa for *My Alohas* magazine.

From our daily farming practice we learn about nature—the need for listening, diligence, learning from mistakes, and patience. We become attuned to nature's balance, the seasons, and our place on Earth. Being part of this local ecosystem inspires all who come to Gingerhill Farm to learn more about indigenous Hawaiian life. I started to practice hula and Hawaiian chanting with Kumu Keala Ching, my Hawaiian culture and hula teacher, to deepen my understanding of island culture and agriculture. *Kumu* literally means "source and teacher."

Kumu Keala Ching, my Hawaiian dance and culture teacher (2012). Photo by Roshi Joan Halifax.

Papaya Blues

In the 1980s, Hawai'i Island native Dennis Gonsalves had just begun his research career at Cornell University when he learned that the papaya ringspot virus (PRSV) was rapidly advancing toward the Big Island's papaya-growing district. PRSV is a pathogenic plant virus characterized by the yellowing and stunting of the crown of the trees, a mottling of the foliage, and small darkened rings on the surface of the fruit. Gonsalves initiated a research project that, in six years, developed genetically modified papayas resistant to the virus.

Genetically modified organisms (GMOs) are living organisms whose genetic material has been manipulated by humans, creating combinations of plant, animal, bacteria, and virus genes that do not appear in nature. It's not the same as grafting or selective breeding. We are part of a highly integrated, natural system, and splicing genetically engineered DNA into a plant destabilizes genetic sequences that have evolved naturally over

millions of years. Genetic modification changes the RNA (ribonucleic acid, which is essential in gene expression) of a plant; it's a technology with many uncertainties and significant evidence of potential hazards, including possible mutations in humans and animals. While GMOs were started with the right intention—such as helping protect papaya plants from a virus—the practice has become widespread and dangerous.

There are other solutions to feeding the world (and providing energy) that work in tandem with nature, but they require us to slow down, listen, and work in partnership with the natural world, rather than as its masters. The real agenda of the people in power is global corporate control of food, water, and energy.

Wind blows GMO seeds through the air, which contaminates other fields, just as GMO salmon that escaped human-made salmon farms into the waters of the Pacific Northwest are likely to contaminate the native fish. We tested papayas that were growing on Gingerhill Farm, and the results showed the defining blue bruise that indicates GMO contamination. With leadership from my neighbor Nancy Redfeather, we formed an organization called Hawai'i Seed to protest GMOs and protect our farms from cross-pollination.

Once all fruits and vegetables are contaminated, seed damage will cut us off from access to natural food—which is no future at all. The University of Hawai'i at Mānoa is a center for GMO research and works with high-tech seed, food, and chemical companies to foster a food monopoly. Through Hawai'i Seed, we wanted to change the laws governing GMOs. We embarked on an education campaign, publishing a handbook called *Facing Hawai'i's Future* to provide legislators, activists, community leaders, and voters the information needed to save healthy agriculture from the grip of corporations. Our efforts have helped open the eyes of politicians and citizens to the dangers of GMOs. There have been many initiatives in Hawai'i to curtail the use of GMO seed production and plant adulteration. The opposition is relentless and well funded, yet we continue to provide solid information to let the truth be known. Wherever we are, the fight continues.

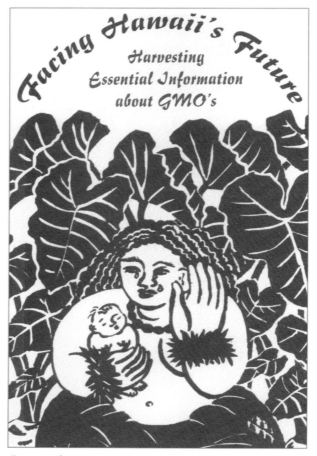

Cover art for *Facing Hawai'i's Future: Harvesting Essential Information about GMOs* handbook, edited by Nancy Redfeather with Solomon Robert Nui Enos.

Nanjing Massacre Anniversary

In 2007, on the seventieth anniversary of the Nanjing Massacre, Kazuaki Tanahashi and Professor Haru Murakawa of Kansai University organized an international conference at Nanjing University in China called "Remembering Nanjing." The Nanjing Massacre was an episode of mass murder and mass rape committed by Imperial Japanese troops against the

residents of Nanjing, then the capital of China, during the Japanese invasion of China in 1937 and 1938, resulting in the deaths of many thousands of Chinese.

The Nanjing Massacre continues to be a controversial subject between China and Japan, and their differing views of history strain the relationship between our two countries. I attended the conference with my friend, the Zen priest Roshi Joan Halifax from Upaya Zen Center, who moderated the women's symposium "Sino-Japan War and the Nanjing Tragedy." Joan and I visited the Nanjing memorial site on the Yangtze and toured museums that commemorated the massacre, studying the photos, stories, and artifacts.

At the conference, forty Japanese attendees, on behalf of our fathers and grandfathers who committed these unspeakable crimes, apologized. We brought a bouquet of blue lotus flowers, along with incense, and placed a white cloth on the staircase at the Nanjing Massacre Memorial Hall. Then the forty of us went to the altar there and made an offering of peace. From this high cliff, we saw the long river and could imagine thousands of Chinese victims forming a bridge of corpses. We sobbed uncontrollably and held one another. Standing there, I could feel the bones of the dead lying on the river bottom, and I apologized from the depths of my heart—not only for the Nanjing Massacre but for the primal sin of being human. Acknowledging the long-buried shadow of my people in Nanjing was deeply healing for my heart and I think for the hearts of the Chinese attendees as well.

Return to Painting and a Near-Death Experience

After ten years of arduous work, Gingerhill Farm had become abundant, and I felt ready to paint again. Design Work Studio in Nara offered me an exhibition in 2010 called *Invitation to the Buddhist Utopia: Tenjukoku*. Adapting Japanese drawing techniques from classical Yamato-e, I used Japanese materials, sumi-e, and ancient pigment on Yoshino paper with a special brush made by a Nara artisan. The exhibit was launched to commemorate 1,300 years since the building of the capital in Nara. Shosaku Yoshimura, who mounts scrolls for temples throughout Japan, mounted

Working in my home studio, painting the *Hanuman* thangka (2016). I brought this to Mauna Kea in 2016 and 2019 to support the Protectors of Sacred Hawaiian Mountain, Mauna Kea. Photo by Roshi Joan Halifax.

my paintings in the traditional way using silk cloth. I painted bodhisattvas, Buddhist figures, Quan Yin, and some vegetables. Learning these ancient Japanese art methods offered me the chance to explore my roots while expressing the freshness of a new utopian Buddhist vision.

When I finished the paintings for the show, I joined Joan Halifax's annual journey of "medical nomads," a trip where Roshi Joan takes doctors, nurses, and aides to open clinics in rural Tibet and Nepal, offering treatment in various villages and monasteries. The journey was *supposed* to end with a circumambulation of Mount Kailash.

Ninety of us, including seven doctors and nurses, and sixty sherpas walked with yaks, horses, and goats over the Nepali mountains. When we reached eleven thousand feet, my knees started to give out, and I was offered a small horse to ride. The Nepalese saddle was so hard and ragged, it barely stayed on the horse, and I couldn't find a stable sitting position. Toward the end of my first day on it, the horse saw a young girl walking toward us and got scared and reared. I fell backward and my boots got caught in

the stirrups. Suddenly I was doing a backbend off the horse, my legs and bottom still riding horseback while my upper body was being dragged along the trail.

As the horse bolted across the mountainside, my head kept banging on the rocky ground. I knew I was in peril of brain damage or even dying. Time stretched, then stopped, and I was able to keep my head safe holding it in both hands, thinking that if my hands broke, I could still paint holding a brush in my mouth. I saw my guardians and deities—Paramahansa Yogananda; Swami Yukteswar Giri, Yogananda's teacher; Babaji; Jesus Christ; Krishna; Onisaburo Deguchi; and my father—watching over me and saying, "Don't worry. There are important tasks that still await you in this life. You won't die now." I relaxed, still bent backward, and continued to be dragged until the horse stopped naturally after about seventy feet. My hands and arms were so bruised, purple and red, that the chief sherpa insisted I be helicoptered the next day to a hospital in Kathmandu.

Roshi Joan Halifax, Abbot, Upaya Institute in Santa Fe, New Mexico (2012).

We spent the night camping in Limi Valley in the Humla district of northwestern Nepal. Under the cold, clear sky, the stars were unbelievably vivid and beautiful. I was deeply grateful to have survived. In the morning, a shiny red helicopter flew me over the pass that had taken two and a half weeks to cross on foot. We flew over Annapurna and Pokhara to Kathmandu in six hours, and I was driven to the international clinic. Doctors took x-rays and fortunately didn't find any broken bones or brain damage. I spent ten days with a sherpa family, resting deeply and also visiting temples, tea shops, and other local places. It was a beautiful retreat. Sadly, these places were destroyed by the recent 2015 earthquake.

Limping with a cane, I returned to Nara for my exhibition, having not made it to Mount Kailash.

Earthquake, Tsunami, and Fukushima

Preparing for the exhibition in Nara familiarized me with traditions of Japanese painting I hadn't known before, and I was left wanting to study these methods more deeply. After the exhibition, I took the scrolls to my gallery in Honolulu. The gallery owner, Robyn Buntin, called the curator of the Honolulu Museum of Art, who agreed to curate a show in the pavilion for Japanese art *and* one for Buddhist art. It was a huge space, and there was much more I wanted to do to explore in traditional ways of painting. Hiro Minato, from Design Work Studio in Nara, joined me to help design the show. We had a year to prepare, which is a short lead time for an art exhibit.

I decided to recreate the drawings from *Random Kindness & Senseless Acts of Beauty*, a poem-story I'd illustrated, with text written by Anne Herbert and Margaret Paloma Pavel, as an antinuclear statement. Published in 1993, right after I became an activist, the *Random Kindness* artwork was inspired by the *Chōjū-giga*, a twelfth-century scroll featuring rabbit and frog caricatures. For the Honolulu exhibition, I made larger, more colorful scrolls, working hard at my studio at Gingerhill Farm, grinding inks and painting for nearly a year. When I finished, I took the drawings to Yoshimura-san's studio in Nara and asked him to mount the screens and scrolls. As I walked out of his studio, I received a phone call from my sister-in-law in Hawai'i. "Are you all right?" she asked. She told me there had been a major earthquake and tsunami in northern Japan.

That night I would be traveling for a planned trip to Morokino near Kansai, Japan, which was farther north of where the quake was.

Morokino had been a major lumbering area after the war, and before that a station on the sacred route that pilgrims walked en route to the Ise Shrine of Amaterasu. The village chief had invited me to join him in inspiring local residents toward innovation in restoring their village. We hung a number of goddess thangkas for an exhibit called *Goddesses Return to Morokino Village*, to invoke the idea of bringing the feminine back to the village.

Random Kindness & Senseless Acts of Beauty written by Anne Herbert and Margaret Paloma Pavel, with my illustrations. First published in 1993 by Volcano Press.

My first night there, we heard that the earthquake and tsunami my sister-in-law had told me about had triggered a meltdown at the Fukushima Daiichi reactor, something I'd feared for a long time. I felt that Japan was doomed. Because the direction of the wind and rain was southward, some areas of Tokyo had become more toxic than places in the north, where the disaster was taking place. Concerned about radioactive particle drift, for five days I sent food, water, air-filter masks, batteries, and other emergency items to my family in Tokyo.

When it was time for me to go back to Hawai'i, foreign travelers had created a mob scene at Tokyo's Haneda Airport, trying to get tickets home to flee the radiation. Somehow I was able to fly home to Hawai'i. As I arrived at the airport in Kona, my friend Aka Iolani Pule phoned, saying, "Come over to Kealakekua Bay. We need to clear debris out of the water."

The tidal wave from Minamisanriku Bay near Fukushima had come

four thousand miles to our small bay in Hawai'i. Seven homes, six cars, and numerous possessions along the shores of Manini Beach, south of Kona, had been destroyed. One house was completely swept off its foundation and into the bay. We volunteers cleaned up debris from the once-pristine reef, using kayaks to shuttle rubbish to shore. The windows, doors, and timber from the house ended up requiring thirty-six truckloads to be hauled away.

If that's what it took to clean our small bay thousands of miles away, I couldn't imagine the massive cleanup that would be needed to make northern Japan pristine again. And it was even harder to envision how whole villages and families—in shock from the deaths of fifteen thousand people and displacement of one hundred thousand—could ever be whole again. My heart went out to my homeland. I chose to title my Honolulu exhibition *A Prayer for the New Birth of Japan*.

Amaterasu, the Sun Goddess

I saw a great opportunity to transform our terrified, fossil-fuel-addicted nuclear economy into a love- and solar-based civilization. I had felt like this for a long time, but the disaster made me realize it more. For 268 years, during the Edo period, Japan had a peaceful, self-sustaining culture. Amaterasu, the sun goddess—a symbol of light, wind, and plant growth—was revered as our mother. During that period, a huge number of people, young and old, would take weeks or months at a time to visit her shrine in Ise, singing and dancing to her along the way.

Amaterasu is still the symbol of our life force and reminds us that we can harvest wind, geothermal, and solar energy rather than digging into Mother Earth's belly and spewing toxic gases that are poisoning us now and depriving future generations of a clean planet. Our first-rate science and technology and the discipline and effort of egoless minds can establish renewable energy and organic food solutions in Japan. It was my prayer for the show that my paintings could help inspire the transition from a fear-based culture into a love-oriented culture, inspired once again by Amaterasu. We needed change, and I felt we as a society were ready.

At the opening ceremony of my Honolulu exhibit, a Shinto priest from Izumo Shrine in Hawai'i, a Shingon Buddhist priest, and the Hawaiian Kumu Keala Ching performed blessings. The exhibit was on display for eight months. For the closing ceremony, my Hawaiian friend, artist, and filmmaker Meleanna Meyer was to chant and Joan Halifax to recite the *Heart Sutra*.

At the end of November 2012, two months before the closing ceremony, my brother, the sculptor Masayuki Oda, died of heart failure. Because Joan Halifax was already planning to be in Hawai'i, I asked her to join Aka Pule, our family friend and Hawaiian wisdom keeper, in performing his memorial service. Floating on the water in two double-hulled outrigger canoes, we chanted the *Heart Sutra* and scattered Masayuki's ashes along with flower petals into the ocean. When we arrived back at Gingerhill, a huge rainbow arched over our house, and my youngest son, Jeremiah, started screaming, "I loved you, Uncle!"

That day, Joan took a photograph of G—we called Jeremiah, my second son, G—with the *Heart Sutra* tattooed on his chest. G had gotten this tattoo in Los Angeles before he came back to Gingerhill. This would be the last portrait taken of him.

Jeremiah (G) with *Heart Sutra* tattoo, Hawai'i (2012). Photo by Roshi Joan Halifax.

My Son Disappears

When I fell from the horse in Nepal, my guardian angels told me I had a lot more to do in my life, and I was wondering what that might be.

When my sons were in their twenties, they rented a twenty-thousand-square-foot building on Potrero Hill in San Francisco and lived there together. Zach, working as a fireman then, renovated the loft and managed the space. They called it "Boys' Loft," and it became a popular gathering place for young people.

G was a graffiti artist and graphic designer who designed colorful skateboards as art director for a skateboard company. He was a skateboarder, but his main passion was spray-gun painting all over San Francisco. Signing his work "Kid Krush," he created masterful works on buildings as high as three stories.

When G was twenty-six, he burned out from his exciting and exhausting life and was diagnosed with bipolar disorder. I set up a silk-screen studio in the San Francisco loft to be closer to my sons, and G worked as my printer. Zach took care of him, but the cool, foggy Bay Area winters triggered his depression. So, after I bought Gingerhill, G came to Hawai'i and helped me take care of the farm.

In 2009, G married his girlfriend, Bizzie Gold, at Gingerhill. We had a feast from our abundant garden. They lived nearby, and G became a great swimmer, diver, and fisherman who gave most of his catch to friends. He talked and laughed a lot, and everyone loved him.

Bizzie got pregnant soon after. She had a home birth, and the infant didn't breathe for the first fifteen minutes because of an error made by the midwife. My son did mouth-to-mouth resuscitation on his newborn daughter, Sarai, to keep her alive. We rushed her by air ambulance to the hospital in Honolulu, where her condition was stabilized.

Sarai grew into a beautiful, perfectly fine, smiling child, except she had a little trouble eating. After ten months, we learned she had cerebral palsy (CP). Her motor skills were affected so that eating, holding things, and walking were hard for her. But she had an incredible gift for smiling with

her body and soul. G and Bizzie could not find skilled CP body trainers in Hawai'i to help her function optimally.

G, Bizzie, and Sarai soon moved to Los Angeles to get access to CP body trainers. Bizzie began teaching Buti Yoga, leaving G at home to paint and take care of Sarai. Sarai was like a child from God, and G was an angel caring for her. Eventually Bizzie became a celebrity trainer and began working with a famous actress. Jeremiah didn't thrive in the urban atmosphere. During their third winter in Hollywood, his deep depression returned. He was no longer able to take care of his baby, and Bizzie needed to work to pay for Sarai's CP training. G felt lost.

He came back to Hawai'i to restore his strength and serenity. He loved his daughter so much and missed her greatly. I spent January 2013 with G in my studio, painting a commissioned work of the sea goddess Yemanja listening to the sound of the ocean in a conch shell. Yemanja was worshipped by the Yoruba people for her protection of women and is the patron saint of childbirth. Her name means "mother whose children are like fish."

I had a hard time painting the exact image of the shell. While I painted, G told me stories about his fear and sadness of not being able to achieve his potential. "I'm sorry I couldn't be good enough to fulfill my work as a painter," he said. I grew to understand more about his anguish and struggles, and I felt his pain.

During that time, I was called to collaborate on a project in Okinawa. Refugees from Japan, especially mothers and children, had fled there after the Fukushima Daiichi nuclear accident as a safe place to give birth and raise children. They'd come from as far as Tokyo, because radioactive contamination in the air was spreading. Midwives were gathering in Okinawa to create a safe birthing clinic and requested my help. I knew I had to go.

On January 30, 2013, while I was in Okinawa, I received a phone call from Zach. "Mom!" he said. "G is missing in Honaunau Bay." Zach insisted I stay in Okinawa until a helicopter search was completed. During the hunt for G, I stayed in a Quan Yin temple, chanting the *Heart Sutra*, and I began Quan Yin practice.

G and his best friend, Jeff Albert, had shared incredible adventures in

Hawai'i. Once they caught a 485-pound, 12-foot black marlin off of South Point on Hawai'i's Big Island. G carried it back to their truck on his back. Honaunau Bay was the "home ocean" for these dear friends. They knew every crevice and could read every wave. G was a man of the ocean, a great fisherman and masterful diver. He had an incredible physical capacity to swim and dive, so he must have experienced something like a blackout.

When Jeff learned that G was missing, he took the first dive to search for him. He found a perfect conch—a Pacific triton, a special shell used by Japanese shamans and Hawaiian royalty—one that Jeff had been seeking for ten years. That day was also Jeff's birthday.

Rescuers searched Honaunau Bay for five days and nights, but my son's body was never found. There was not a thread of a swimsuit, his snorkel, heavy diving belt, or anything. He was completely gone. The day he passed away in the sea was the ceremonial day to honor Yemanja, the goddess of water. Three months before G's passing, he had tattooed the mantra of the *Heart Sutra* in Sanskrit, interwoven with the design of a Hawaiian lei, across his chest. The sutra says, "*Gate gate paragate parasamgate bodhi swaha!*" (Gone, gone, gone beyond, to the other shore, awakening fulfilled, oh great joy!). Soon after, I realized the true meaning of this sutra: freedom from suffering. There is no life; there is no death. There is only this moment of pure truth, just a continuation of love and the spirit of oneness. This was a gift G gave me.

In March, we went back to Green Gulch Farm Zen Center, where my children grew up, for G's life celebration. Abbot Steve Stücky conducted a beautiful Buddhist ceremony and gave him lay ordination, naming him Blue Depth Dragon Ocean. G's friends from childhood made a massive pagoda, and after his memorial service, we carried it along the path to Muir Beach, a rugged stretch of pristine sand. At the ocean's edge, we offered white flowers to him and Yemanja, then his friends set fire to the pagoda. It burned like an inferno into the sky, smoke curling up into the full moon. While carrying Jeremiah's spirit away, the smoke washed away our grief and sadness too. Now he is with me all the time.

Return to the Village

When I was growing up in a Tokyo suburb, the neighbors maintained traditional farming practices, living in harmony with the seasons. We were next door to a thatched-roof farmhouse. In spring, skylarks from the wheat fields would fly through the clouds and blue sky. In summer, we picked tomatoes under the bright sun. Then, the sound of thrashing grains and the color of red persimmons would signal autumn.

When my sister and my two brothers were born, I went to get the midwife when my mother went into labor. We took care of my parents and grandparents in their old age at home, and they died at home. Young and old, birth and death, all were a part of our life. The last night of every year, all the tenant farmers gathered with the landlord and together they pounded mochi (glutinous rice). The time I spent with the old aunties on the farm was priceless; they taught me about life. The farm had a small shrine to Inari, the Shinto god of foxes, fertility, rice, tea, sake, agriculture, industry, general prosperity, and worldly success; the shrine was decorated with tiny fox figurines.

By the 1960s, around the time I left Japan, the city was already closing in on our suburb, pushing out traditional ways of living with nature. Family farms and small shrines disappeared. In addition to the loss of balanced, land-based values, our extended families became nuclear families, with just parents and their kids living in cramped apartments rather than three or four generations living together. Making a living to afford a house and pay for children's educational needs is expensive, leaving little time or space for well-being and fulfillment. Shopping centers and malls have become our hunting-and-gathering grounds. People eat fast, lifeless food made cheaply and efficiently in factories, contributing to the loss of both family farms and people's nutritional health. Consumption of fruits and vegetables grown on industrial farms using pesticides, herbicides, and GMO seeds may correlate with decreased fertility in both men and women. We rely on unsafe, imported food, disconnected from clean water and nutrient sources, putting everyone at risk. No wonder some people feel alienated and lonely.

There are still rural villages in Japan, but most of the farmers there are in their eighties and nineties now. Their children have moved away. With the comforts of city life, the wisdom and discipline of living naturally have eroded. Remembering the way I grew up, I wanted to find ways to keep traditional values alive before they disappear entirely—values such as honoring neighbors and helping one another, fulfilling ways to live and to thrive. So, I initiated a "Goddesses Return to the Village" campaign in Japan, to encourage people to go back to a slower-paced, saner, happier life.

I started visiting places where the people already felt as I do about sustainability, scouting for potential sites to create a renewed village. In the 1960s and '70s, many people returned to villages to live mindfully. Even then they were feeling fed up with city life, just as they were in 2013 when I made my way to the village of Morokino. There we offered a sustainability campaign to inspire villagers to return to healthier lifestyles, but Morokino was too remote and it was too expensive to restore the whole area. We weren't able to realize our dream there, but still I held on to the idea.

We tried again when I had another show, which I called again *A Prayer for the New Birth of Japan*, in 2013 on Nushima Island in Hyogo Prefecture. This island is said to be the birthplace of our nation, so I thought it would be a perfect symbol to regenerate village life there. Nushima is a small island fishing community with a diminishing population about to lose its school system. I envisioned people moving to the island to start afresh, but I was naïve. The islanders were not ready for change. I tried to find a big, open lodge for our center, but the local people were against renting to an outsider. Anything we did was met with resistance. It helped me realize that going back to a traditional village was not the way to do it. The Morokino and Nushima experiments were both costly and remote. There was no way for young people to make a living there, despite my fundraising.

So, we focused instead on engaging modern people in the new natural lifestyle. We did art shows and seminars about the solar-hydrogen future, but again we were unable to manifest our dream. One Nushima project collaborator, Mana Tanakadate, traveled with me after the Fukushima

Daiichi disaster to the west of Japan and the island of Kyushu to research countercultural farms started in the 1960s and '70s, as well as new sustainable villages. Mana found that these back-to-the-country idealists were much happier and healthier than their city counterparts. They didn't have to work as hard, they supported one another, and they had more time for music, dance, and fun. We were offered a three-acre piece of land only fifteen minutes from Nara, and it seemed to be exactly what we were looking for. In 2014, Mana rented it, and I agreed to help with the fundraising. First we had to name it.

The Little Forest of the Toyouke Goddess

Mana and I visited Ise Shrine, where Naigu, the inner shrine, is dedicated to the service of the sun goddess Amaterasu, and the outer shrine, Gegu, is dedicated to Toyouke, the goddess of agriculture and fertility who brings offerings of food to the sun goddess. Shintoism is based on gratitude—being thankful for what we eat, especially in relation to the sun, which provides us with nourishment. In the legends, when Amaterasu was looking for a place to live, she chose Ise. She called Toyouke to come from the north to live with her, and they've been together for 1,500 years. To this day, Shinto priests dressed in white make food offerings every morning and evening, even in times of war, earthquakes, and typhoons, performing rituals of gratitude to the sun goddess.

There was a fishing village with a salt field nearby, where shellfish such as abalone were gathered. All these foods were beautifully prepared to serve the goddess. Together, land- and sea-based activities were known as the "Happiness of the Sea" and the "Happiness of the Field," in service to Amaterasu. Harvesting food from the fields and preparing it carefully for the goddess with prayers to the sun to complete the full circle of life is the essence of Shinto and the way Japan keeps the Shinto tradition alive. Honoring Shintoism was important to us, and we decided to name the farm Toyouke No Mori, "the little forest of the Toyouke goddess." Mana wrote these words for our fundraising proposal:

PURPOSE OF TOYOUKE-NO-MORI

In Nara, at the birthplace of ancient Japanese culture, we women can inherit and pass on the natural farming principles and philosophies of our ancestors.

Through farming, cooking, and eating, we receive and appreciate blessings from the heavens and the earth and become one with Mother Earth who cherishes all forms of life.

While networking nationally and internationally, we are living in harmony with nature and creating a space for sustaining and spreading the traditions of the beautiful culture of Japan.

In May 2014, in the fresh green of spring, Toyouke No Mori held a three-day festival in which the goddess thangkas were exhibited in the fields, forests, and hills. I was excited to fundraise with Mana, the original founder, because we were both committed to helping women establish value-added businesses using the bounty of the land and sustainable ways of living. Toyouke No Mori is now a successful bed-and-breakfast

Hawaiian cultural practitioners and other protectors, including myself, gathered for noon protocol at Puuhonua o Puuhuluhulu (sacred site at Maunakea) protest against what we call desecration of the mountain by the planned construction of the TMT Telescope (2019). Photo by Molly Peters.

with Chie' Noda as its director. Chie' worked in a traditional Japanese inn in Kyoto and studied Japanese-style hospitality, and she invested all of her retirement savings to create very comfortable accommodations where guests can experience beautiful traditional Japanese hospitality. Farm friends have helped create wonderful gardens where we grow fruits, vegetables, and rice. Wellness workshops there inspire visitors who want to expand their knowledge of sustainable living.

This is the "Goddess Returns to the Village" I originally envisioned. Even though Morokino and Nushima seemed like failures at the time, I see now that they were essential for developing and realizing my dream.

Happy Now, Happy After

There is no "happily ever after" such as we read about in fairy tales. We continually have to work for it. After twenty-five years with the antinuclear movement, I discovered that not far from where I live in Hawai'i is the center of the Pacific Rim military training ground, the US military's Pōhaku-loa (Big Rock) Training Area. This weapons-testing site sits between two sacred volcanoes, Mauna Kea and Mauna Loa. My farm is downwind of their target practice.

Residents of the island are coming together on Mauna Kea to offer prayers in hope of bringing the land into balance. In Hawaiian, this balance is known as *pono*, being one with the universe. Hawaiians practice *kapu aloha* there. *Kapu* (taboo, literally "sacred") is used to mean "forbidden" (as in "no trespassing") because something is sacred. *Aloha* means love. To create change, we need to unite kapu and aloha to create the bridge between shadow and light. Hawaiians also practice *ho'oponopono*, making things right or whole.

Standing Firm with Love for Mauna Kea, Kapu Aloha, August 2019

Shortly before this writing, I went to Mauna Kea, our highest and most sacred mountain, to be with many of my close Hawaiian friends and fellow

activists who are protesting to stop the construction of the Thirty Meter Telescope (TMT) there. My friends, my family, and I have been involved over the years as activists or protectors, as we consider ourselves to be, and we are proud to join this real Hawaiian movement for standing firm with love.

This conflict has gone on for many years. Astronomers see Mauna Kea as one of the best locations for gazing into deep space, as it is the highest mountain in the world when measured from the ocean floor. But for native Hawaiians, Mauna Kea is sacred ground, meant to be protected and preserved to benefit the sustainability of future Native Hawaiians.

And so, the protectors have gathered there, on the mountain, or *mauna*, that has already been desecrated many times before by other observatories and by poor planning, broken promises, and lack of respect for the wishes of the native Hawaiian community. Mauna Kea protectors are protecting the now (the present time) and preserving the future.

I took my Hanuman thangka to the protest. Its title is *Hanuman Guardian and Protector of the World, Over Big Island, Island of Rainbows, in the Center of the Pacific, Holding the Earth in His Hands*. I took it to the mountain once before when it was painted, in 2016, specifically to support the protectors of Mauna Kea, with whom I stand in solidarity.

My Hanuman is in honor of the fire monkey, who brings passion, creativity, and truth. I dedicate this thangka to those who work to tell the truth and to give young people hope for the future. I do so to inspire their passion and creativity to visualize the future in more positive ways for this world that we live in together.

May we protect the now and preserve the future.

A Vision for the Future

Our modern world is invested in fear, which is a natural response to disaster, but it's difficult on the body and psyche to live in a culture in which we are in fear 24-7. It's time to acknowledge the harm fear causes and begin discerning what is real from what is exaggerated. To do this, we need to face our collective fear, to see it and feel it. When we do, we discover that it

is always born out of suffering. Recognizing our fear will help us heal the poisonous legacy J. Robert Oppenheimer described so vividly when the bomb he helped create was first detonated, and which has grown larger and larger over the past seventy-plus years.

Making art and engaging as an activist in the name of the goddess has, at times, been disheartening, but I see the small victories as stepping-stones that can take us further along the path Sarasvati offers us.

At the Little Forest of the Toyouke Goddess in Japan, the spirit of the goddess is being reborn. We're also working to make Hawai'i a mecca of non-GMO food safety. Laws and initiatives have passed, only to be struck down in the courts, but anti-GMO activists continue their crucial work. Hundreds of my goddess paintings and scrolls are on display around the world. *The Safe Energy Handbook* (twentieth-anniversary edition) and *Facing Hawai'i's Future: Harvesting Essential Information about GMOs* are helping people understand the nature of the two-headed beast—nuclear energy and GMO contamination—we have to face.

Where we go from here depends on our vision—whether we can see hope to support the "feminization" of this so-called civilization. I believe healing will happen. Our children are the fruit of the culture we helped create in the 1960s and '70s—women's liberation, spiritual transformation, Buddhism, Taoism, Hinduism. They are gifted, wise, and understanding. They are our hope for the future, and they understand that information is power, and that power belongs to the people—it is no longer limited to special groups. This power, along with our innate wisdom and closeness with the earth, will bring a great healing. We don't yet know how it will take place or how long it will take to transform our fear-based civilization, but we are entering a more compassionate and creative era. We need patience. And I feel Sarasvati telling me we can succeed.

Afterword

OUR MOTHER EARTH is stirring. While I've been writing this book, the world has gone through a massive upheaval and is entering, in my opinion, a new era. Global climate change has accelerated the need for alternative energy sources. White nationalists are defending the last gasps of patriarchy.

To do no harm was the basis of my father's philosophy. Live creatively, he told me, it's the basis of freedom, as long as we take responsibility for our actions and don't harm others or the planet. I bow to that sentiment, as well as to the *Heart Sutra* that has taught me about oneness with nature and all beings in the universe. This divine knowledge, compassion, and wider scope of consciousness is needed now to make a difference. It creates miracles and synchronicity; it is the divine matrix connecting us to our purpose.

In January 2016, as I was finishing this book, my son Zach and his wife, Iris, were in Brazil studying sustainable farming. The responsibilities of Gingerhill Farm were left to me, and I continued my writing at night. Fearing the toxicity from the Pōhakuloa Training Area's depleted uranium drift floating downwind to our farm, Zach and Iris left with the hope of finding a safe place to start a family. Eventually they realized that toxicity is everywhere, that no place is truly safe and devoid of pollution, and so they returned to Gingerhill Farm wholeheartedly becoming masterful guides teaching sustainable agricultural practices.

As I completed my manuscript in the early hours of the morning, I had a stroke. With focused effort I have recovered most of my capacities, but the experience made me realize that my time for creativity—writing and making art—is limited. I want to use the rest of my time on this earth for creating. I believe this is the most beneficial way I can offer my time and skills to reach others and affect change.

I was born under the shining star Venus, the mother abode of Goddess Sarasvati. When I sit quietly, I can receive the life force deep within, letting Sarasvati work through me. When I'm unsure what to do, I return to sitting. In the early morning, I gaze up at Venus and feel at home.

The gods in my country of origin were restored during the Meiji Restoration and then destroyed by Westernization. Now is the time to restore the gods and goddesses again, all over the world, by being deeply in touch with nature, spirit, ourselves, and one another. Now I'm in my late seventies and back to painting and growing organic food, practicing random kindness and senseless acts of beauty.

In 2018, I took the Shugendo Mountain shamanic path to revisit the Tenkawa Shrine. I was surprised to find the priests of the temple doing a fire puja, burning wood to create an enormous white fire. When the smoke was lifted by the wind, I saw all my friends from the antinuclear movement—artists, musicians, and so many others—drumming on taiko drums they'd made from deerskin from around the mountain. All the people I worked with in the movement were there.

I hope this story and the work of so many other women warriors move people's hearts and inspire young people. It will be really hard to clean up the mess we've left for you. I trust you will bring forth the changes needed to transform our civilization from fear to love and will find solutions to the immense challenges we face today.

Recently, archeologists in India uncovered the mythological Sarasvati River. This ancient vein under the earth, thought to be buried for thousands of years, never stopped flowing. Sarasvati is calling us to reawaken.

When I see the night sky, I see my home the Pleiades and I know what to do. In Japanese tantric astrology, it is believed that Earth is the eighth star of this constellation. This is our place in the solar system, from the Milky Way to the Valley of the Ancestors.

May you find your place.

I am there for you. Always.

Acknowledgments

MY DEEP APPRECIATION to all who made it possible for this book to exist. Thank you to:

Robert A. F. Thurman for his beautiful foreword. Emily Nathan for her wonderful contribution at the beginning of the book.

Shambhala Publications for publishing this book, including Matt Zepelin, Breanna Locke, and Rachel Neumann.

Many thanks also for editing assistance from John Nathan, John Einarsen, Stephanie Guyer-Stevens, Thais Mazur, and Arnie Kotler.

And to all who provided photos for the book: Ushio Katsuhiko, Hiroshi Teshigahara, Arthur Dresden, Angela Longo, Roshi Joan Halifax, Yuko Ishikawa, and Dana Fineman.

My longtime friend Toshiko Asai of the Kyoto HUB who was with me when I started my antinuclear work.

To Inochi board members, especially Kazuaki Tanahashi, Claire Greensfelder, and Fusako de Angelis.

Dania McManus Wong, my secretary, for her assistance throughout the process.

And to my family, my son, Zachary Nathan, and his wife, Iris Lami, for their love and support.

Mayumi Oda

Goddess Returns to the Village, a three-day festival at Toyouke No Mori, Nara, Japan (2014). Photo by Masatoshi Okamoto of Design Work Studio.

About the Author

MAYUMI ODA is a groundbreaking Buddhist teacher, painter, and activist who doesn't separate her art, activism, and Buddhist practice. Born in Tokyo in 1941 to a creative, sophisticated family steeped in art and Buddhism, Mayumi has been an artist her entire life. From an early age, she was sent to school for art, calligraphy, and English. Even before her Tokyo University studies, where she was a design major in Japanese traditional decorative arts, Mayumi had a very good background in painting and drawing. Later she studied printmaking at Pratt Institute in New York City.

Known as "the Matisse of Japan," Mayumi has exhibited over fifty one-woman shows throughout the world from 1969 to the present. Her artwork is part of permanent collections at the Museum of Modern Art (New York), the Museum of Fine Arts (Boston), Yale University Art Gallery (New Haven, Connecticut), the Library of Congress and the Smithsonian (Washington, DC), and Los Angeles County Museum of Art, among many others.

Mayumi cofounded Plutonium Free Future in 1992. On behalf of this organization, she lectured and held workshops on nuclear patriarchy to solar communities at the United Nations NGO Forum and the Women of Vision Conference in Washington, DC. In 1999, she helped launch the WASH (World Atomic Safety Holiday) campaign, and she works to raise awareness among the citizens of Hawai'i about the use of depleted uranium at the US Army's Pōhakuloa Training Area.

In 2000, after she had spent the last ten years as an antinuclear and non-GMO activist—which instilled an urgency to create a farm for growing clean, uncontaminated food—she founded Gingerhill, a farm and retreat center on the Big Island of Hawai'i. She converted Gingerhill Farm into

the verdant, botanical oasis where she lives and creates her art and writing today.

In 2011, her son, Zachary, moved from Brazil with his wife, Iris, to take over as the directors of the farm. Since that time, they have worked hard to develop a productive and harmonious community dedicated to wellness and education with a mission to inspire people to reconnect with nature and be kinder to themselves, their neighbors, and the planet.

Zach, Iris, and me at Gingerhill Farm in Kealakekua, Hawai'i (2019). Photo by Dana Fineman.